IMAGES
of America

FEDERAL WAY

# Federal Way Area

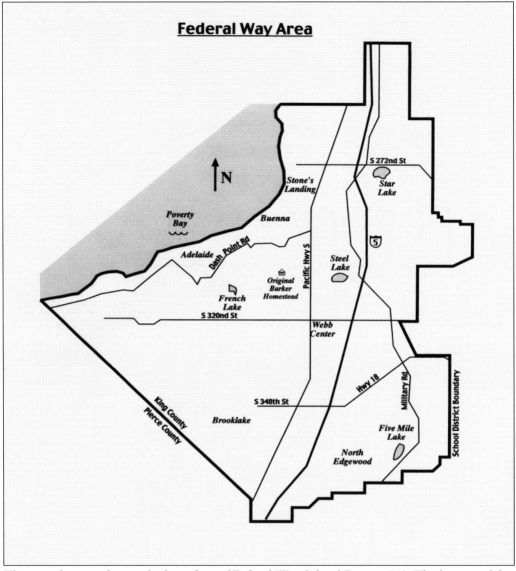

The area shown indicates the boundary of Federal Way School District 210. The history of this area, although larger than the city of Federal Way, was used in this book to develop the history of Federal Way. Some of the early sites mentioned in the book are shown. (Courtesy Don Hagen.)

**ON THE COVER:** The Brooklake Hillbillies was an organization of the Brooklake Community Club that enjoyed participating in plays, dances, fairs, and other community functions. In this 1950 photograph, members sit on a horse-drawn wagon preparing to participate in a local parade. The group was promoting the upcoming Brooklake Fair. (Courtesy Carol Huston.)

IMAGES
*of America*

# FEDERAL WAY

Historical Society of Federal Way

ARCADIA
PUBLISHING

Published by Arcadia Publishing
Charleston SC, Chicago IL, Portsmouth NH, San Francisco CA

Printed in the United States of America

Library of Congress Catalog Card Number: 2008930684

For all general information contact Arcadia Publishing at:
Telephone 843-853-2070
Fax 843-853-0044
E-mail sales@arcadiapublishing.com
For customer service and orders:
Toll-Free 1-888-313-2665

Visit us on the Internet at www.arcadiapublishing.com

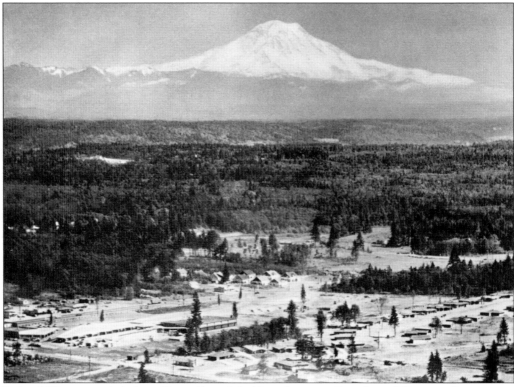

Federal Way is nestled along Puget Sound, halfway between Seattle and Tacoma. Picturesque Mount Rainier is a mere 40 miles away. This 1954 aerial photograph shows the new Federal Shopping Way in the foreground and Mount Rainier in the distance. The undeveloped area is the present designated city center. (Courtesy Evelyn Cissna.)

# Contents

# ACKNOWLEDGMENTS

This history of the city of Federal Way, developed by the Historical Society of Federal Way and published by Arcadia Publishing, would not have been possible without the help of many people.

Our sincere appreciation goes to the following: Marie Sciacqua, who directed the project and scanned the images; Dick Caster, who wrote chapters 3, 4, 7, and 8, the introduction, and a brief overview on the back cover; Ann Hagen, who wrote chapters 1, 2, 5, and 6; and Diana Noble-Gulliford, who wrote chapter 9. Don Hagen provided the map/illustration. Barbara Barney and Lynda Jenkins contributed their expertise and knowledge to the history. Ed Opstad catalogued the photographs, and Ed Streit provided scanning techniques. Nancy McEleney, Evelyn Cissna, Jim Chambers, Shirley Opstad, and H. David Kaplan helped with proofing and editing. The City of Federal Way, 4Culture, and Wal-Mart provided financial support.

Many thanks also go to past historians like Marie Reed and Ilene Marckx, who left photographs and pages of handwritten and typed information. Thanks are also due the many people who provided photographs from their private collections. They are acknowledged on the individual pages. Those pictures without attributions are from the archives of the Historical Society of Federal Way.

Lastly we thank those who have contributed to our historical collection. Anyone with photographs or information that illustrates Federal Way's history is encouraged to contact us at www.federalwayhistory.org.

# INTRODUCTION

The city of Federal Way, Washington, is located between Seattle and Tacoma along the Interstate 5 corridor. Mount Rainier is to the southeast and Puget Sound to the west. During the early years, and even up until city incorporation in 1990, the boundaries of Federal Way were always loosely defined. In order to have a thorough understanding of the history of the Federal Way area, the Historical Society of Federal Way decided at its formation in 1988 that the Federal Way School District 210 boundary offers the best way to develop the history of the present city of Federal Way. The school district covers 35 square miles, while the city of Federal Way covers 22.5 square miles. Therefore, the area discussed here is actually about 55 percent larger than the city of Federal Way. Because of the use of the school district boundary, the area includes all of the city of Federal Way, some of the cities of Des Moines, Kent, and Auburn, plus some unincorporated areas of King County.

Around 18,000 years ago, the area of Federal Way was covered by ice up to 4,000 feet thick from the last stages of the ice age. By 10,000 years ago, the ice from the Vashon Glacier was mostly gone and the area began to look much like it did when the first settlers arrived. The retreating ice left the area full of marshes and rocky soil.

Native Americans never settled in the Federal Way area because there are no navigable rivers and there was very heavy forestation. The Muckleshoot Indians, who lived in the Auburn Valley around the White, Stuck, and Green Rivers, traveled through the area to get clams from Puget Sound. They often camped at the beaches along Puget Sound, particularly at Poverty Bay, where shell middens have been found.

The first non–Native Americans to come into the area were loggers, who in the 1860s began to take advantage of the easy access by water to remove the timber from within a few hundred yards of Puget Sound. By the 1880s, about 50 homesteaders had filed claims in the Greater Federal Way area. By 1890, another 50 homesteads could be found. People clustered into several small pockets and lived isolated lives. For example, while Stone's Landing on Puget Sound had about 50 people in 1890 and Star Lake had about 30 people, no one lived in the 2-mile area between them. In the 1880s, the U.S. government also sold a considerable amount of land to the Northern Pacific Railway Company as a land grant payment for bringing railroads to Washington Territory. While the Northern Pacific Railway Company did not build any passenger or freight lines here, they owned considerable land through these land grants. They sold off this land as 40-acre tracts to private individuals. While many homesteaders were successful in developing their land, others gave up their homestead claims before they had worked it the required seven years for full possession.

By the mid-1880s, Stone's Landing, because of its easy water access, became the first actual community with families and businesses. Prior to the first large dock being built around 1900, small boats had to row out to the steamers to board and unload people. This community grew south with people settling in Adelaide and Buenna close to the water.

Families also clustered around Star Lake in the north and an area called North Edgewood in the south about this time. The North Edgewood group was fairly well settled between the King-

Pierce County line and what is now South 360th Street. The area around Steel Lake was settled by 1890. Since each of these areas was isolated from the others, they developed their own one-room schools. Stone's Landing, because of the water access, was the one central location that all the people used. Access for many of them was difficult, requiring a several-mile walk.

Inland travel was difficult due to a lack of roads. Roads developed slowly. They were normally muddy and full of holes and difficult to build because of the heavy forestation. Old Military Road, originally developed in 1855, was for a long time the only major road between Tacoma and Seattle, even though it was just a dirt road. Gradually residents built some crossroads. This enabled people to go from Stone's Landing to Auburn. In 1913, King County took over building the roads and the system began to expand. Roads were still dirt. In 1915, a federal highway, now known as Pacific Highway South, opened as a dirt road for car transportation between Seattle and Tacoma. The east half of Pacific Highway South was paved in 1927, and the west half of the double highway was completed in 1930. Even until the late 1920s, there were few roads that could be easily used by other than animal-drawn vehicles. Other than a few main thoroughfares, paved roads within communities started to develop only in the 1940s.

The early settlers were mostly law-abiding, hardworking people who helped each other and relied on their own initiative. The soil was glacial till full of various sized rocks that made it hard to cultivate extensive acreage. Large areas were covered with marshes, and there were 10 lakes. Most of the settlers had a small garden, a cow, and some chickens. The small quantity of vegetables that settlers could raise had to be supplemented by purchased staples. The first store was at Stone's Landing, with the next closest one being in Kent about 10 miles away. A small store operated out of the Crotts' house at Star Lake until 1900. Prior to roads being cut through by settlers, a trip to Kent or Auburn, only a few miles away, would take a full day.

Hunting was good for the first few years, but by 1900, most of the deer and cougar had been killed. Prior to 1910, the woods were full of black bears.

By the 1900s, many settlers found they could only support themselves by working elsewhere. Some found jobs as loggers. Others went into Seattle or Tacoma, where they found work at a trade, as domestics, or teaching school. This required them to spend the week away from their families and be home only on weekends. Travel to the job was difficult. Most walked several miles through the woods to catch a steamer at Stone's Landing. By 1900, steamers had a regular schedule between Seattle and Tacoma, with stops at several in-between places such as Stone's Landing. Some settlers rowed from Stone's Landing to Tacoma in an effort to save money.

Some commercial farms had begun by 1912. The commercial crops of the time were tomatoes, cucumbers, and leaf lettuce. Some berries and chickens were also sold. To reach markets in Seattle and Tacoma, these vegetables were hauled on steep primitive roads down to Stone's Landing, put on a boat, and sent to Seattle or Tacoma. Many found it necessary to load their farm products on rock sleds and skid them through the woods to the nearest roads where they could be loaded onto trucks.

Social activities centered on getting together for an evening of cards or dancing. At first, settlers gathered in each other's homes. Everyone brought sandwiches and cakes. They stayed until daylight so they could see to go home through the woods. Most folks walked, but a few had horses. It often took from one to two hours to get to the party and that long to go home. As the gatherings increased in size, homes became too small for dances and parties. The communities started to erect meeting halls. One of the first was the International Order of Good Templars (IOGT) Hall at Star Lake. The Templars were a popular lodge on the West Coast in the early 20th century and had halls in most cities. The IOGT Hall was torn down in 1918. By 1920, Grange halls were a common center of activity. Once these halls were open, residents had a place to put on various types of programs. Schoolhouses also became a venue for dances and programs.

Religious activities were also important and took place in available facilities, such as schools and Grange halls. Three large religious campgrounds developed for holding religious services and camping.

Around 1920, women began organizing women's clubs, which expanded into community clubs that also included men. Activities were available for everyone, including children. In addition

to providing for various fun activities, these clubs undertook projects to help people in need. When the Depression came in 1929, the women's clubs and community clubs were a stalwart of support for the hard times.

One of the major fears in the small, isolated communities was fire. Conflagrations came from two sources. Forest fires could race through the highly wooded areas. A blaze in 1886 is known to have caused much devastation in the North Edgewood area, and many homes were lost. The use of lamps, candles, fireplaces, and machinery also posed as hazards. These items often led to an individual house or barn being burned. Since there was no organized fire protection, the home or barn was usually a complete loss. Neighbors helped with rebuilding, but many people gave in to the hard times and left the area.

The Seattle-Tacoma Interurban Railroad ran between Seattle and Tacoma, with many stops in between. The tracks were just east of Federal Way. Many people would walk from all over Greater Federal Way to catch the commuter train at the stop in the Jovita area or even to the Auburn and Kent stops. This commuter line operated from 1902 until 1928. There were also at least three logging railroads. One of these, built around 1913, started at Stone's Landing and worked its way in a northeast direction, crossing present Pacific Highway South around South 272nd Street, and continued east and north around the east side of a swamp near Star Lake. Another logging railroad ran from Milton to Peasley Canyon Road just east of the present Commons at Federal Way Mall. The third logging railroad ran to Dumas Bay near the present Dash Point State Park area. Currently there are no railroad tracks in the Greater Federal Way area.

Pacific Highway South developed into the main north-south highway on the Pacific Coast between California and the Canadian border. When new businesses began to form in the 1930s and 1940s, they were usually built along Pacific Highway South to serve motorists. The driving trip between Seattle and Tacoma took several hours, and since Federal Way was about halfway between the two cities, it was a good location for restaurants and gas stations.

Federal Way started growing for several reasons. Around 1936, many of the old homestead lots were broken up into smaller lots to meet a growing demand for land. People desiring lakefront and rural acreage were moving from overcrowded Seattle. The second reason was World War II, with the housing shortage for workers in Seattle and Tacoma war production plants. The third was the development of the Seattle-Tacoma International Airport in 1946 that forced many families out of their homes south of the airport. The fourth was the general expansion of population in the county by 1950, which made outlying areas popular for commuting into Seattle and Tacoma. Federal Shopping Way opened in 1955 as the area's first large, centralized collection of stores. With the addition of SantaFair in 1962, it tried to be a combination shopping center and Disneyland. But in a few years, it went into bankruptcy. Consistent and fairly rapid growth has continued since the 1970s.

The beautiful Puget Sound area known as Federal Way is fortunate to have not only a rich history to present, but also a history that is still being written. Today Federal Way is a full-fledged bustling city and the home of 88,000 people (200,000 people if the entire population of the school district is used).

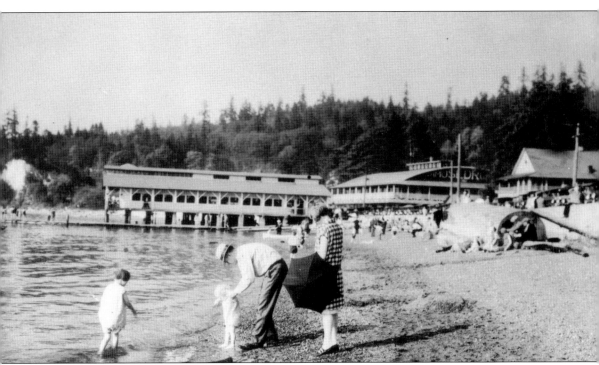

A family of four enjoys Redondo Beach in the early 1930s. The lightly forested hillside shows little evidence of what is to come. During the next 75 years, the hillside will be replaced by permanent homes, condominiums, a county park, and walkways. The following pages about Federal Way's early beginnings at Stone's Landing will help the reader become better acquainted with local history.

# One

# STONE'S LANDING AND REDONDO

The beautiful Puget Sound area now known as Redondo was well known long before settlers arrived in the mid-1800s. Native Americans passed through periodically, collecting berries, fishing, and digging for clams. Capt. George Vancouver sailed near the area in 1792. But it wasn't until Sam Stone homesteaded in about 1871 that the area acquired its first name, Stone's Landing. The Stone family, along with others who arrived, was primarily interested in logging. It was an ideal location. Five-hundred-year-old trees were abundant, and waterways for transporting logs were near. Loggers set up a small sawmill near the beach and then floated the timber to a log boom during high tide. The logs were towed to larger mills in either Seattle or Tacoma.

By the late 1800s, steamships were chugging through Puget Sound between Seattle and Tacoma, transporting supplies, equipment, and visitors. People soon recognized that Stone's Landing and its public beach combined to be a wonderful recreation area.

Progress was on its way. In 1904, Charles Betts opened the first store, which had a shop downstairs and rooms for rent upstairs. The community's name was changed to Redondo in 1906 following a tragic accident that killed 13 people. About 2,000 people were in town when the pier collapsed as many of them waited for a steamship. Betts selected the name Redondo because he envisioned a recreation area like Redondo Beach, California.

By 1911, Redondo's population had reached 200 persons. There were two restaurants, two churches, and a number of businesses. A seawall and road had been constructed to make way for visitors and Model Ts. A new dock had been built, and homes were beginning to appear on the shore.

Betts's plans to turn Redondo into an entertainment/resort town were materializing. He brought in a Ferris wheel, carousel, and miniature train. About 1922, he and his son Weston built an Amusedrome that included bowling and dancing. Later it was converted into a recreation center and roller-skating rink before burning to the ground in 1951.

As the entertainment business slipped away, Redondo changed. There is little left to remind one of its vivid past. Condos have replaced old businesses, modern homes dot the shore, and rush-hour traffic continues nonstop. But people still head to the beach. It is a beautiful place to visit.

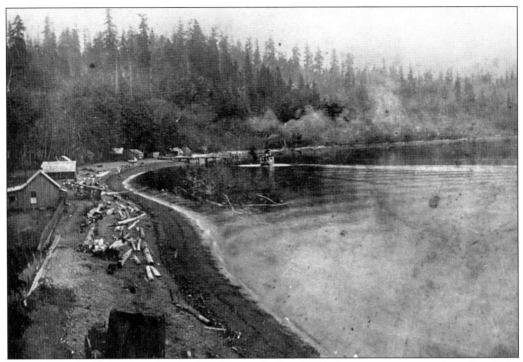

A steamship heads north to Stone's Landing in the late 1890s, bringing visitors and supplies. The ships gradually became so plentiful in Northwest waters that some said they looked like swarms of mosquitoes. Thus they were called the "Mosquito Fleet." (Courtesy Byron Betts.)

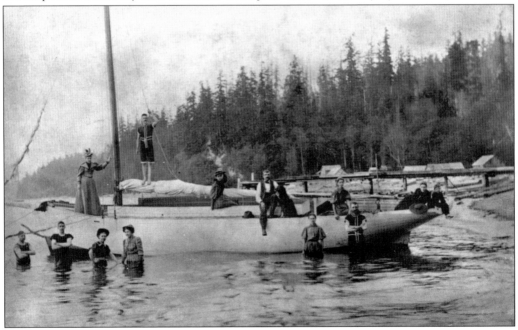

In the late 1800s, a group of Auburn teachers pose on and in front of a large sailboat as they enjoy a picnic at what would soon be named Stone's Landing. (Courtesy White River Valley Museum archives.)

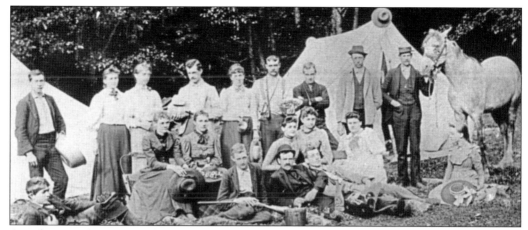

A gathering of 19 men and women set up camp near the beach in the early 1900s using sturdy canvas tents or tarps thrown over branches. Stoves were comprised of sheet iron placed over rocks; blankets were laid on stacked fir branches. Getting to the beach from nearby communities was a vigorous task, so many people stayed for days, weeks, and even months at a time.

Isaac (left) and Ida Hurd pose in front of a residence in Stone's Landing that also served as a post office, restaurant, and bakery. The first post office at Stone's Landing opened on February 12, 1899, with postmaster Joseph P. Bucey. The name was changed to the Redondo Post Office on October 8, 1904. Hurd became postmaster at that time. (Courtesy Weston Betts.)

Logs along the Stone's Landing beach are tossed like giant toothpicks during a severe 1906 storm. The second building from the right was built by Charles Betts in 1904 and was the first store. The store was on the first floor, and second-floor rooms were rented to loggers. Early owners included Charles Zeigler (1910) and Carl and Margaret Lindstrand (1941). The building was demolished in February 1990. (Courtesy Byron Betts.)

The King County Directory, posted in 1911, lists the following businesses in Redondo: "Bretts & Horner, gen mdse; S. P. Brokaw, Methodist Church pastor; Henry Bucey, lawyer; Isaac Hurd, postmaster, restaurant and bakery; Jean McElroy, teacher; I. F. McKirahen, gen mdse; S. J. Brokaw, Methodist church pastor; Edna Pursey, music teacher; Frank Thompson, carpenter. Additional businesses include Ryan's Inn, and the Redondo Union Sunday School." (Courtesy Office of Historic Preservation, Seattle.)

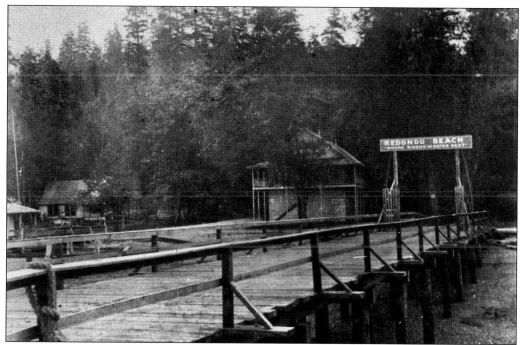

A sign on the pier in the early 1900s says, "Redondo Beach, Where Woods and Water Meet." Charles Betts, an early pioneer and one of the area's first developers, renamed Stone's Landing to Redondo in 1906 after the dock collapsed, killing 13 people. Betts didn't want the stigma of the disaster to discourage people from visiting the area. (Courtesy Weston Betts.)

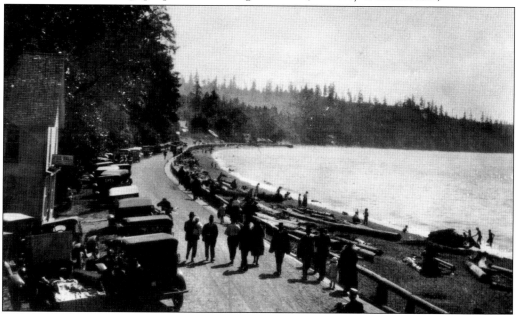

By 1911, a seawall and road were built to contain logs during storms and separate the road, businesses, and homes from the beach. Redondo was already a rapidly growing community with 200 residents. There were two daily mail boats from Seattle and Tacoma. The first Redondo school was built on a hillside above the sound.

Land for the William Hainsworth beach house, pictured here in 1919, was purchased from pioneer Henry Bucey for $1,200. The house was patterned after the Hainsworth House in West Seattle, now a historical building. The remodeled beach house is located at 29015 First Avenue South. (Courtesy Joanne C. Thompson.)

By the early 1900s, Redondo was beginning to thrive as a tourist destination. Charles Betts provided carnival rides; Charles Zeigler owned the grocery store; and Nelce Christenson had a boathouse, bowling alley, and grill. Visitors played and stayed during the spring and summer, returning the community to a peaceful solitude during fall and winter months.

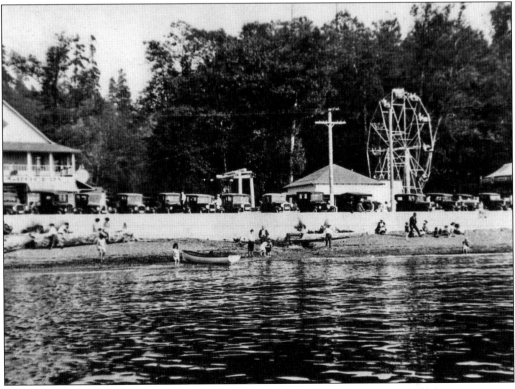

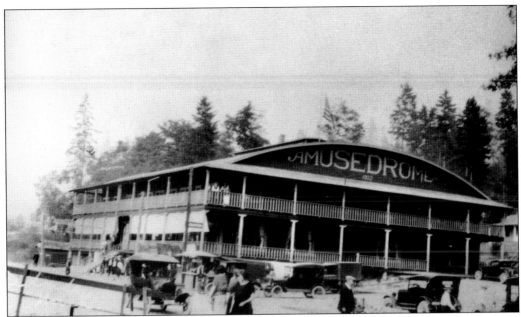

The Betts entertainment tradition continued in 1922 when Weston Betts built the Amusedrome, a two-story building that housed a bowling alley downstairs and a large dance hall upstairs, with ground-level parking supported by pilings. A year-round attraction, the hall was particularly grand and could accommodate a 10-piece band. It was located on property that now houses the Bayshore condominiums.

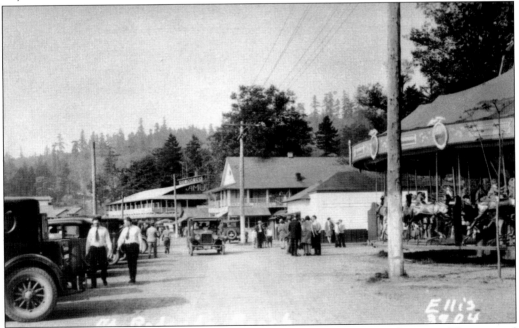

People gather and enjoy Redondo's carnival atmosphere during a sunny afternoon. The carousel at the right was a particular draw. Weston Betts purchased the carousel in 1921 for the Redondo Kiddieland for about $7,000. It was 50 feet in diameter and included 36 horses. It was later used in Seattle, Tacoma, and Federal Way.

After the dancing business dropped off in the 1930s, Weston Betts remodeled the Amusedrome into a recreation center. He eliminated the ground-level parking and added a 90-by-150-foot roller-skating area. It was considered one of the finest in the area and included a Wurlitzer pipe organ that was the largest organ in any roller rink. (Courtesy Byron Betts.)

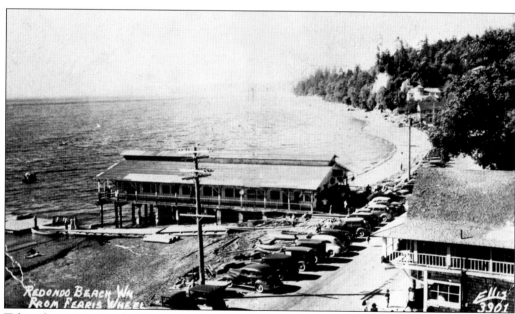

Taken from a Ferris wheel in Redondo, this photograph shows the building that is now Salty's at Redondo. The restaurant, currently owned by Gerry and Kitty Kingen, has gone through many owners and name changes. It was built in 1947 and called Nelce's Boathouse. (Courtesy A. W. Montgomery.)

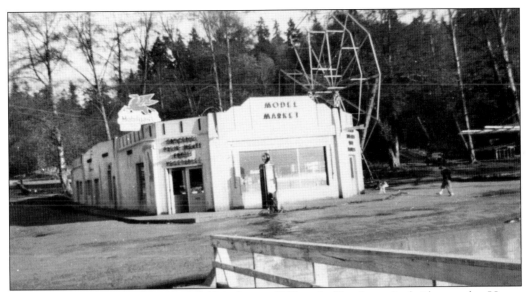

Weston Betts built the stucco Model Market in 1935 and offered carnival rides nearby. Henry Stewart Burlingham operated the market for many years until 1961, when it was taken over by Carl and Vi Kirkeby. A veteran of World War I, Burlingham died in 1963 at the age of 61. (Courtesy Ila Mae March.)

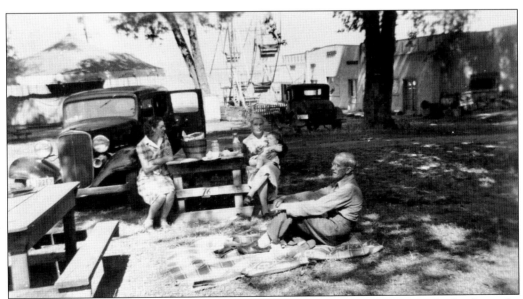

Lenora Hagen (left) and her parents, Iloe and Jay Eastman, enjoy a picnic at Redondo in the early 1940s. Iloe is holding baby Victor Hagen. The Ferris wheel and carousel can be seen in the background. The Hagen family owned a gas station on South 312th Street and Pacific Highway South. (Courtesy Carol Hagen Dooley.)

19

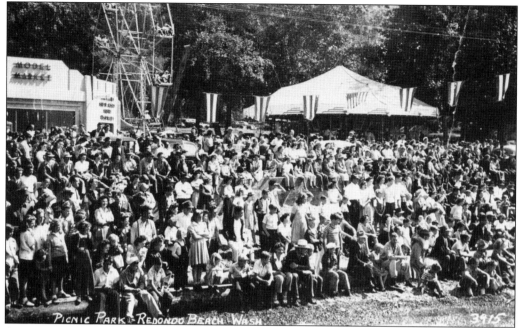

A commercial postcard from 1945 shows hundreds of men, women, and children sitting and standing along the beach and road at Redondo to get a better view. Pictured in the background are the Model Market, the Ferris wheel, and the carousel. (Courtesy Ila Mae March.)

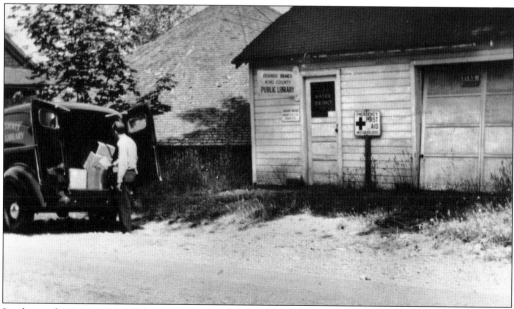

In the early 1940s, a small house in Redondo served as the Redondo branch of the King County Public Library, the water district, and a place to get emergency first aid. A library courier is pictured to the left delivering books.

Byron Betts, son of Weston Betts, who developed the skating arena and the Redondo Beach Park, was active in his father's entertainment business. Here he is pictured piloting the miniature train on a track near the grocery store. The building that formerly stood on the Salty's at Redondo restaurant parking lot can be seen on the left, along with a gas station pump. (Courtesy Byron Betts.)

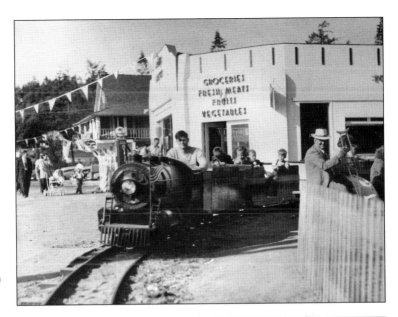

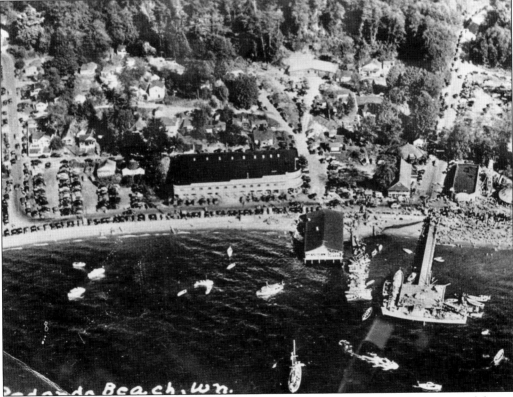

This late-1940s aerial view of Redondo demonstrates the festive atmosphere that occurred during this time. Cars are parked along the northern shoreline, near busy streets, and in parking lots. Boats are anchored offshore as well as at the two docks. The beach south of the dock is crowded with visitors and sunbathers. The popular skating rink is in the center of the photograph near the beach. (Courtesy A. W. Montgomery.)

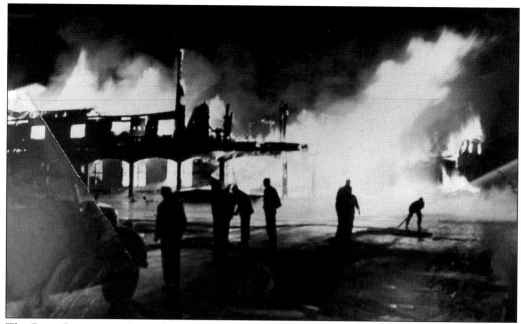

The Betts Recreation Center/skating rink was destroyed by fire in 1951. Arson was considered but never proven. Future generations of the Betts family continued to operate skating rinks in Federal Way, Everett, Kent, Puyallup, and Spokane.

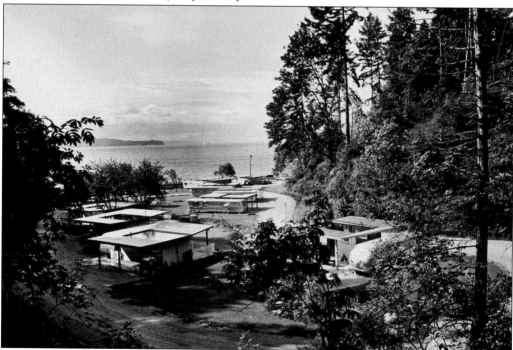

The trailer villa, pictured at the south end of Redondo in 1953, served as permanent and summer housing for trailer owners. The park is now called Redondo Shores and includes large and small permanent homes. A stream called Coldbrook meanders through the park to Puget Sound. Vashon Island is visible in the distance. (Courtesy Nellie Fleming.)

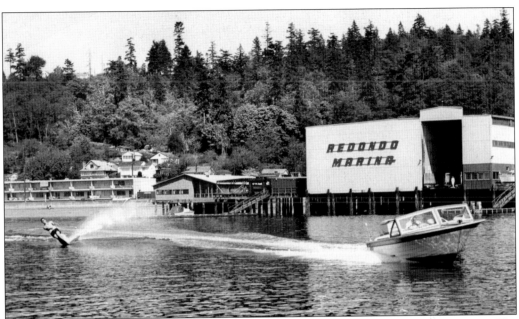

In 1959, Weston and Byron Betts completed a state-of-the-art $200,000 dry storage marina. The complex provided services for at least 250 boats and was considered one of the most modern facilities in the Northwest. Weston Betts sold the property, which included the marina, Mae and Al's Boathouse, and a park, in 1960. The marina was later torn down and replaced by a ramp for boat launching.

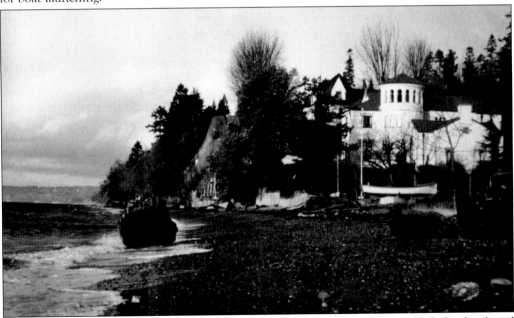

J. R. Cissna lived in what many called "the castle" at Redondo for 18 years while he developed one of the first outdoor shopping centers in the country on the corner of South 312th Street and Pacific Highway South. The "castle," pictured in about 1968, is now privately owned, gated, and nearly surrounded by shrubbery. Expensive homes with waterfront views have been built on both sides of the property. (Courtesy Federal Way School District 210.)

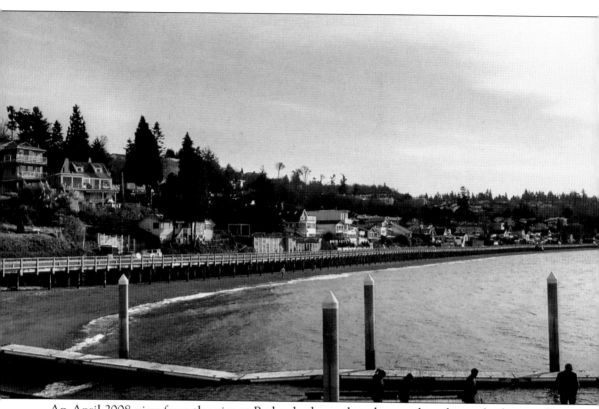

An April 2008 view from the pier at Redondo shows that the area has changed substantially. Most of the small vacation homes are gone, renovated or replaced by large multilevel homes. Groups of condominiums are nestled in the hillside near the original downtown area and along the road. Traffic during rush hours on weekdays keeps the streets busy. But people still love the beach. Throughout the year, particularly during warm spring and summer days, they walk or jog the boardwalk, play on the sand, fish from the pier, practice scuba diving, or launch their boats. Some of them simply sit on logs or nearby benches to soak up the heat and watch the birds. If they are hungry, Salty's at Redondo provides a take-out café and seafood restaurant. Overall, it is still a wonderful place to visit. (Courtesy Marie Sciacqua.)

# Two

# LOGGING

In the late 1800s, the heavily forested area around what would some day become Federal Way seemed like a logger's paradise. Trees 10 to 15 feet in diameter grew abundantly in heavily forested land. Giant firs, spruce, and cedar were available for men willing to work hard and take risks. At that time, there was also a high demand for lumber. Civilization was edging its way west, and people needed lumber to build towns, homes, roads, and businesses. Large sawmills in Tacoma and Seattle could handle all the timber available.

Initially loggers set up logging camps near the lakes and Puget Sound to ease moving logs to a central distribution point. They built "skid trails" to roll logs to the water. Some of the loggers managed yoked teams of five to seven oxen to help drag the timber from the forests. Horses were harnessed to drag smaller trees.

Getting logs to market became easier around 1885 with the introduction of the railroad and steam engines, or "donkeys." Loggers were then able to use the steam engine and a complicated cable system to move the trees out of hilly terrain. By the early 1900s, there were logging camps scattered throughout the area in Redondo: near South 262nd Street and Pacific Highway South; on Steel Lake; between Lake Fenwick and Star Lake; where Peasley Canyon and Military Roads intersect; and near Dash Point Park.

Most logging companies were small and privately owned, though some were owned by major firms such as Stone and Webster Company. Though the Weyerhaeuser Company never logged in Federal Way, it became a major land and lumber investor in 1900 when it joined with other investors to purchase 900,000 acres of property in western Washington from Northern Pacific Railroad. By 1905, Washington produced more timber than any other state in the nation.

By the beginning of the 1930s, logging in Federal Way was virtually finished. Large-growth timber was gone and most of the forests were cleared of all but the smallest trees. But the loggers left a lasting legacy. They not only provided building materials, they paved the way for the future by clearing property for residential and agricultural use and building roads that would eventually become major thoroughfares.

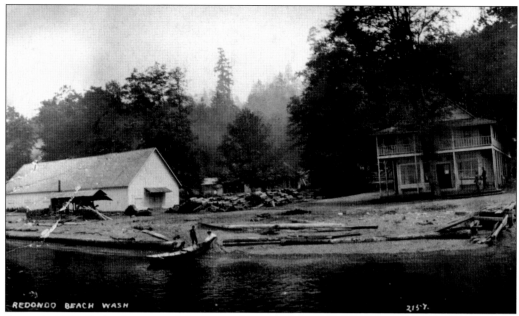

An early-1900s Redondo postcard shows an old steam engine (left) that may have powered a small sawmill operation or been used to cut shakes or shingles. Logs cut into 3- and 4-foot cords are stacked near the mill on the beach. They were often used to power steamships. The photograph also shows two men tending a rowboat, a popular form of transportation in those days. (Courtesy A. W. Montgomery.)

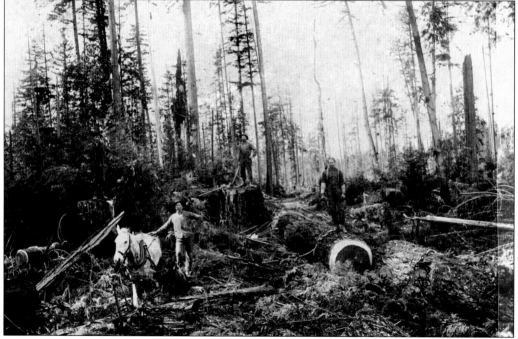

In the late 1800s, loggers typically used teams of five to seven oxen yoked together to pull trees out of the woods. In this photograph, most of the large timber is gone and loggers are attempting to remove smaller trees with the horse.

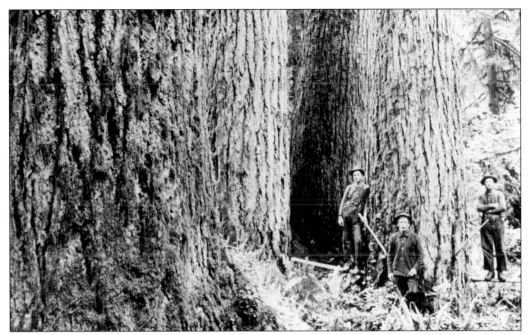

Trees like these, pictured in the late 1800s, were plentiful when logging camps started springing up around lakes and along Puget Sound in Federal Way. A logger typically used two single-sided axes, one for bark and the other for the rest of the tree. Saws were not introduced until about 1870. (Courtesy Earl Chambers.)

Jim and Mildred Chambers and their son Earl are pictured near one of the many logging camps where they cooked during the early 1900s. The couple could feed 150 to 300 loggers three times a day. When grown, Earl continued logging throughout the area and provided many of the photographs in this chapter of the book. He and his wife, Mary, raised their family in Federal Way. Earl was on the local school board from 1956 to 1971. (Courtesy Earl Chambers.)

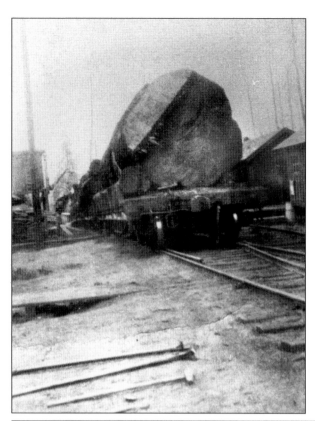

A giant fir awaits transport on a local logging train. Most of the trees that were 10 to 15 feet in diameter were gone by the early 1900s. (Courtesy Earl Chambers.)

James Alexander's Puget Sound logging camp is pictured in 1909. It was located at the top of Peasley Canyon near the old Military Road. James and Mabel Webb Alexander stand near their horse and rig. Most of the men are either loggers or railroad workers. (Courtesy White River Valley Museum.)

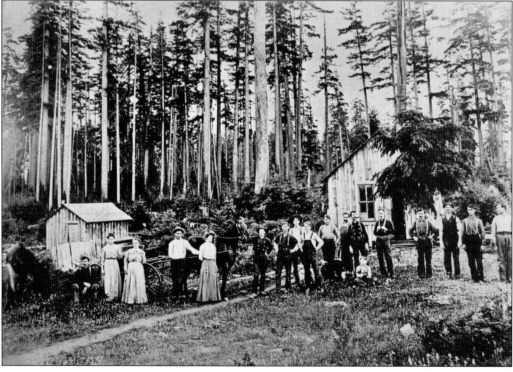

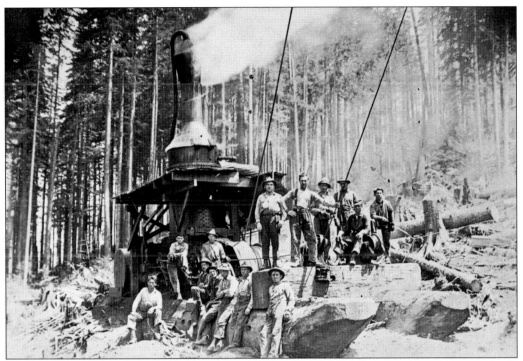

This steam engine was used at Palm Beach near South 333rd Street and Twenty-second Avenue Southwest in the 1920s. Called either a "yarder" or "donkey," the steam engine was placed on skids so it could pull itself through the forest with a cable system. The cables were also used to transport giant trees from hilly terrain. (Courtesy Earl Chambers.)

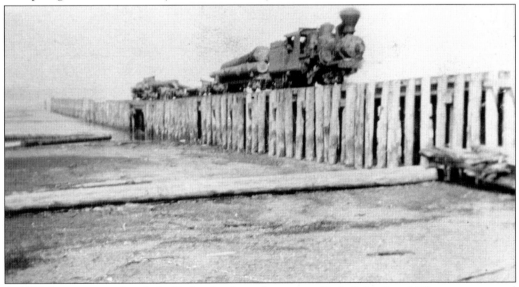

A 1920s logging train heads for Redondo along the present Dash Point Road. There were several hundred logging railroads in the state during the early 1900s, including a company owned by Johnny Mack. Mack's railroad started at Redondo, went east on what is now South 272nd Street to Sixteenth Avenue South and north to South 260th Street. He had 5 miles of track and one locomotive. (Courtesy Earl Chambers.)

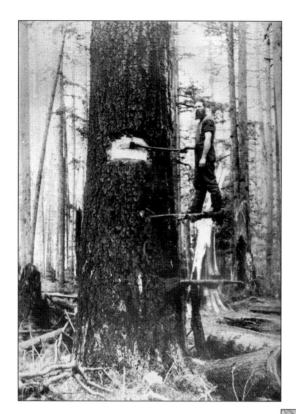

Loggers typically climbed on springboards that were wedged into the tree about 8 to 10 feet up before chopping the tree down. Springboards had sharp metal ends that were jammed into wedges the logger had cut into the tree. (Courtesy Earl Chambers.)

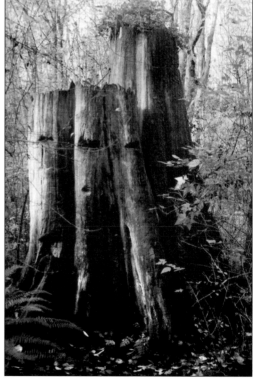

Cedar stumps like this one remaining at Dash Point State Park demonstrate how loggers notched trees prior to cutting them down. Loggers apparently chose not to use the stumps since they were difficult to cut and mill. The stump, about 11 feet high and 5 feet in diameter, is located about 110 yards up a trail that begins at the east end of the parking lot. (Courtesy Ann Hagen.)

In this 1923 Redondo photograph, fallen logs make a nice place to read for pioneer Myrtice De Rousseau, daughter of Claude Barker. Her grandfather John Barker owned the Barker Cabin on display on South 348th Street near the West Hylebos Wetlands Park.

Local logger Earl Chambers is barely visible at the top of a cold deck of logs ready to be hauled out by a locomotive. The 1920s logging site at Southwest Twenty-sixth Street and 327th Street South now includes Olympic View Elementary School and the Twin Lakes and Village Park housing developments. (Courtesy Earl Chambers.)

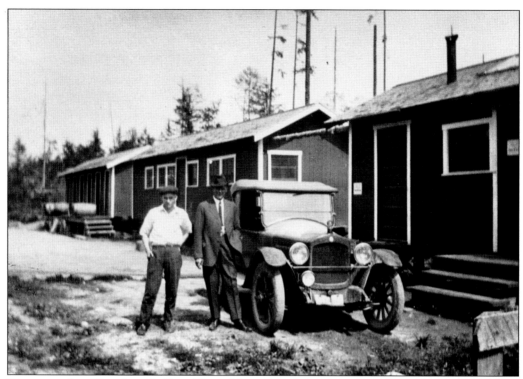

Two men—Jim Chambers (left) and Perry Howard (right)—are pictured near their Hupmobile at a logging camp at Palm Beach near Dumas Bay in the early 1920s. The temporary living quarters behind them were built so they could be easily dismantled or moved on skids to other logging camps. (Courtesy Earl Chambers.)

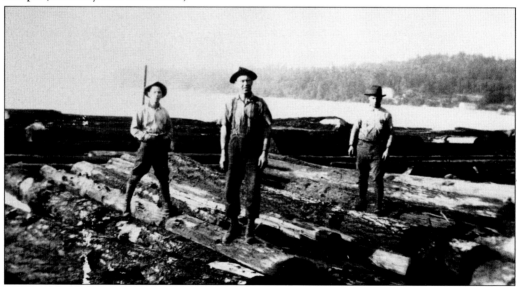

In the early 1900s, Phil De Rousseau stands between two of his fellow loggers on a log boom that would soon be towed to the St. Paul Mill in Tacoma. DeRousseau worked at a Redondo Beach lumber camp that employed hundreds of men. The men often worked 10-hour days for $5. (Courtesy Earl Chambers.)

Two local loggers, including Fred Hanson (right), are pictured in riggers' gear in front of a Douglas fir. Their gear is typical for brave men called "tree toppers" or "high climbers," who climbed to the top of the trees to top them. Both men worked at the Palm Beach logging camp in the early 1920s. (Courtesy Earl Chambers.)

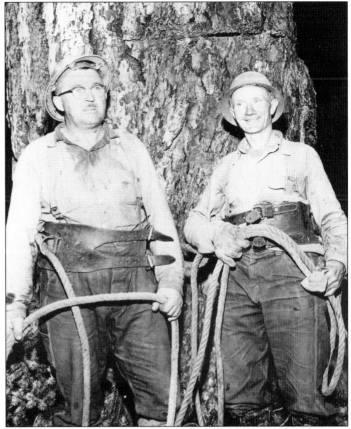

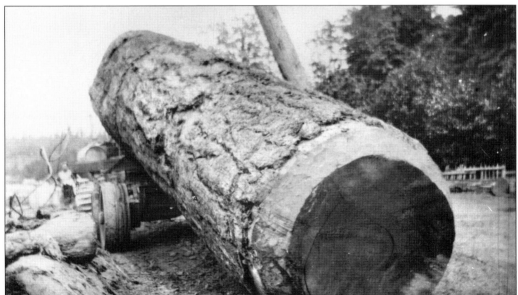

Logs such as the one pictured are typically "sniped" or tapered at one end to ease removing them from the woods. This log is being hoisted by cables attached to a "donkey" or steam engine. (Courtesy Earl Chambers.)

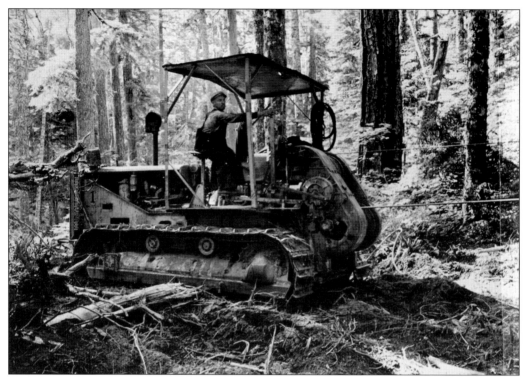

Crawler tractors made by Caterpillar or other manufacturers simplified logging on reasonably level ground in the 1920s. Loggers no longer needed to use oxen or steam engine–powered "donkeys," with cables connected to spar trees, to remove logs from the woods. The cable system, however, was still needed in hilly terrain. (Courtesy Earl Chambers.)

In 1923, loggers load a large log onto a deck of four smaller logs to move the tree down what is now First Avenue South to the water at Redondo. Chains are wrapped around the log to help loggers maintain control. (Courtesy Earl Chambers.)

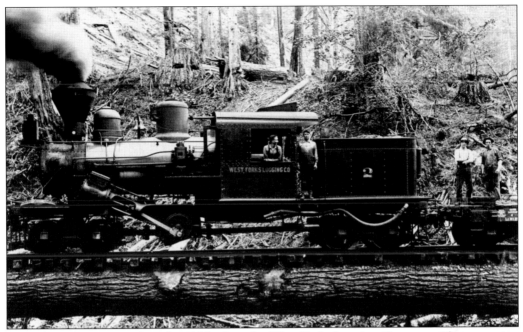

Several men are pictured in the 1920s aboard a West Forks Logging Company Climax engine that hauled timber on old HiLine Road, now Twenty-first Avenue South. A sizable, straight tree provides a solid base for this portion of the tracks. (Courtesy Earl Chambers.)

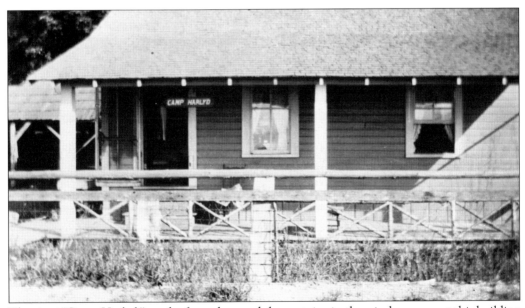

The sign, "Camp Harlyd," on the front door and the curtains in the windows suggest this building was one of the homes used by loggers who worked at a logging camp in Redondo in the early 1900s. (Courtesy Earl Chambers.)

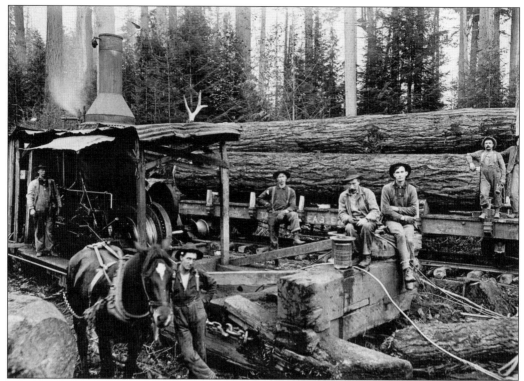

In the early 1920s, Federal Way loggers worked in logging camps similar to the one pictured. After felling trees, loggers hauled them to the train using a complicated cable system powered by a "donkey" or steam engine. The steam engine was on skids that allowed it to slide across the terrain. (Courtesy Earl Chambers.)

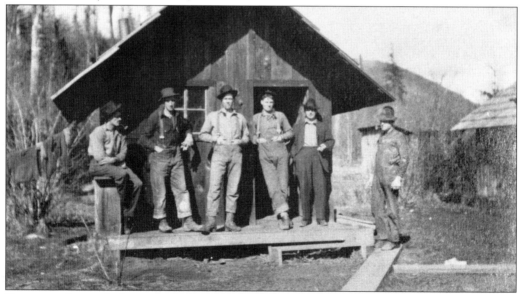

Temporary homes for loggers were built on platforms so they could be moved to another logging camp when the job was done. Taken in 1923, this photograph shows that most of the surrounding hillsides had already been logged. (Courtesy Earl Chambers.)

# *Three*

# FIRST SCHOOLS

When families began settling in the area in the 1880s, they wanted to provide education for their children. Five small school districts developed around separated areas of settlers. Each of these districts had only one school at a time. One private school, St. George's Indian School, provided education to Muckleshoot Indian children from 1888 until 1936.

North Edgewood School District 42 was chartered in 1884, with a school being built the same year. Originally the district boundaries were from the King-Pierce County boundary to what is now about South 356th Street.

Another group of families was clustered around the Adelaide area near Puget Sound. A small uncertified log cabin school, called French Lake School, was built in the mid-1880s somewhere between Mirror Lake and Puget Sound. Even though it was uncertified, it had a paid teacher. Adelaide School District 55 was formed in 1887. The two-story Buenna School was built in the early 1890s to replace the smaller 1887 Adelaide Beach School.

Star Lake School District 64 was formed in 1888 to serve the area around Star Lake. A school was built around 1888–1890. The first three Star Lake Schools are gone, but the fourth is still standing, although it is no longer used as a school.

Steel Lake School District 92 was formed in 1891 to serve the area around Steel Lake. The first school, a small cabin, opened the same year. A schoolhouse was built in 1893.

Redondo School District 169 was formed in 1909, on land from the west side of School District 64, with a school opening the same year.

After World War I, there was a move throughout the state to consolidate the small rural school districts. The five Federal Way area districts were each serving only 25 to 50 students. Combining resources and students from several small districts into one large district improved facilities and transportation and made funding more efficient. It also meant that a graded curriculum could be used instead of having all grades together. The five school districts were consolidated into Federal Way School District 210 in 1929. The vote to consolidate was 214 for and 167 against.

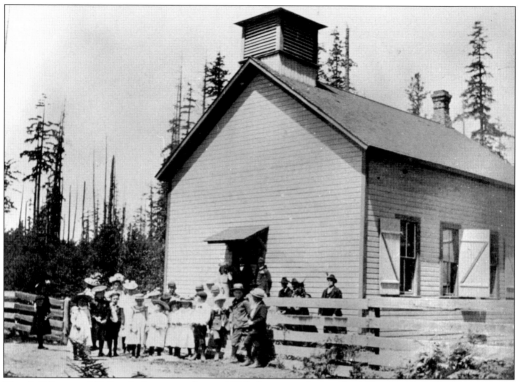

North Edgewood School, shown in this c. 1888 photograph, was built in 1884. It is considered the first chartered school in the area. The school was located near what is now South 360th Street and slightly east of Interstate 5. North Edgewood School operated as a two-room schoolhouse until it was replaced by Harding School in 1920. (Courtesy Marie Reed.)

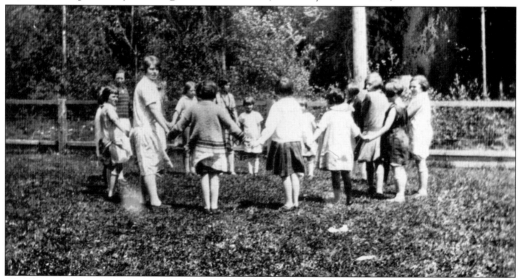

Children play "Drop the Handkerchief" during recess at North Edgewood School, probably around 1915. Records indicate the school served about 25 to 30 students with one teacher and two classrooms. It operated until about 1920, when the Harding School was built. (Courtesy Mildred Sutherland Rawson.)

Fr. Peter Hylebos was active in Tacoma and South King County from the 1880s until his death in 1918. He was involved with both religious and secular development. Hylebos was a leader in supporting Native American rights and education. He raised money, donated land, and found the staff to build and run St. George's Indian School. (Courtesy Archives of the Catholic Archdiocese of Seattle.)

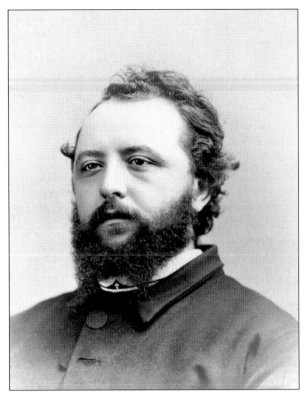

St. George's Indian School opened in 1888 and operated until 1936. This *c.* 1900 photograph shows Fr. Charles DeDecker (back left), the school superintendent, and Father Hylebos. The photograph shows about 55 Native American children in their uniforms along with staff and helpers, both Native American and white. The site is now occupied by Gethsemane Cemetery. (Courtesy Archives of the Catholic Archdiocese of Seattle.)

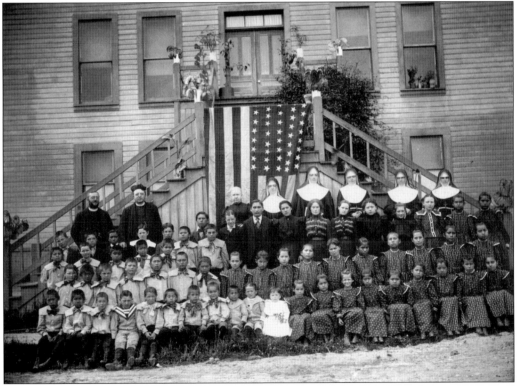

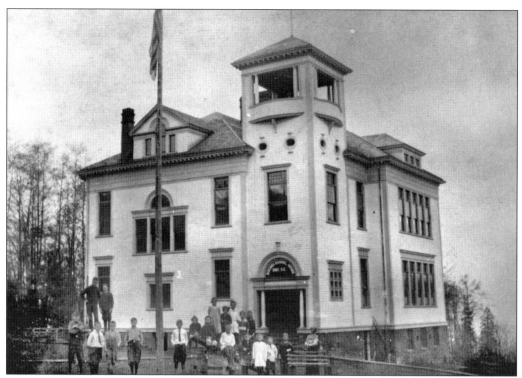

The first school in Adelaide District 55 was a small frame structure built near Adelaide Beach. The increase of the student population forced a second, more permanent, school to be built, and the first one was abandoned. The Buenna School, shown in this c. 1914 photograph, opened around 1893 at what is now Southwest 296th Street between Ninth and Tenth Avenues Southwest.

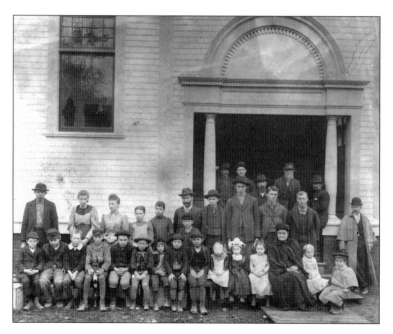

Students, teachers, and some unidentified gentlemen pose in front of the Buenna School in the late 1890s. The school was a grade school, but some high school classes were offered. Even though the building had several rooms, most of the classes used only one room with all grades together. One of the men in the back row could be John Barker, an important early homesteader. (Courtesy Dorothy Rodgers.)

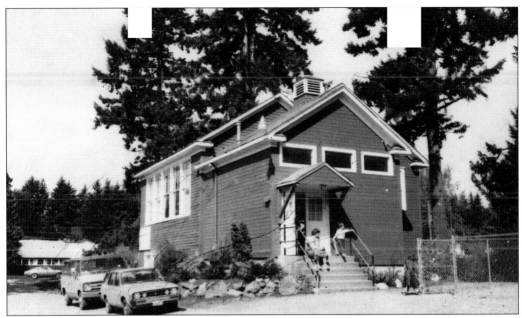

The fourth Star Lake School, built in 1910, still exists at the intersection of South 272nd Street and Military Road. The first two schools were temporary, and the third burned down. Shortly after the school was built, a preacher named Bushell came monthly and preached to local inhabitants. These church services appear to be the first ones documented in the northern part of the Federal Way area. (Courtesy King County.)

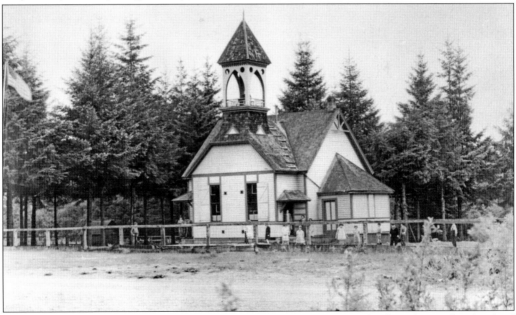

This 1920 photograph shows the Steel Lake School, built in 1893. Like the other early schools of Federal Way, this one operated with one teacher who handled grades one through eight. After 1929, the school fell into ruins. It was burned as a fire-training exercise in 1957. The school was near the southeast end of Steel Lake, at South 312th Street and Twenty-eighth Avenue South. (Courtesy Blanche Schweiger.)

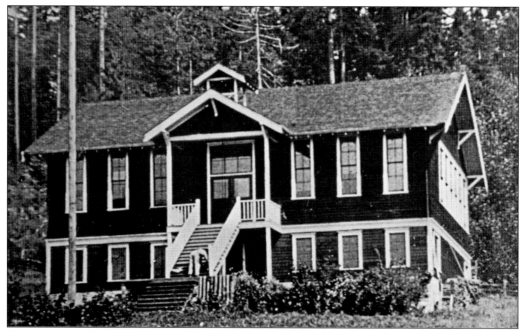

The Buenna School soon became overcrowded. It was difficult for some students to get to the school because of a lack of roads. School District 169 was formed in 1909 from the west side of the Star Lake School District 64. The Redondo School opened the same year and many of the Buenna School students started going to the Redondo School, shown around 1920. (Courtesy Marie Reed.)

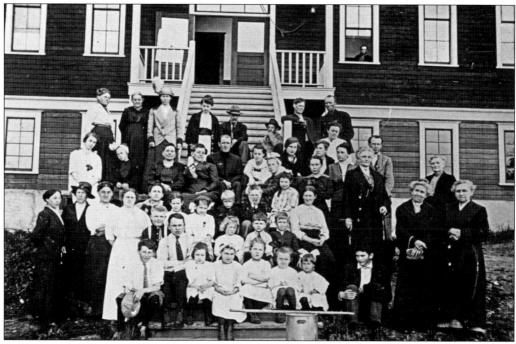

Students, teachers, and parents are shown in front of the Redondo School about 1910. Note the one person looking out the window. The school was located just above the Redondo Beach area along Tenth Avenue South.

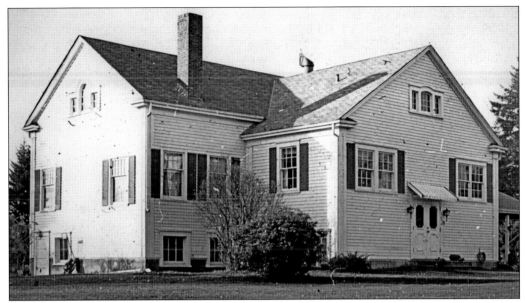

Harding School replaced the North Edgewood School in 1920. This building still exists at South 360th Street and Sixteenth Avenue South. It provides a well-preserved example of Colonial revival architecture, popular in the first half of the 20th century. The building, shown here in 1978, has been used for many community activities and currently is being used as a church.

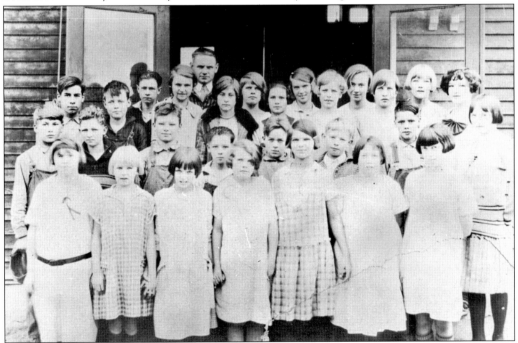

This c. 1927 photograph shows the student body of Harding Grade School. Wade Calavan (back) was the principal, part-time teacher, and bus driver. On the far right (back row) is his wife, Anna Calavan, the full-time teacher. Anna had originally taught at North Edgewood School and taught at Harding School from the time it opened in 1920 until it closed in 1929. (Courtesy Marie Reed.)

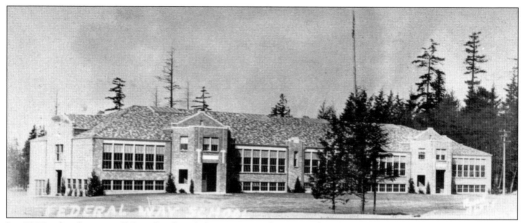

In 1929, the five small local school districts, with one school each, consolidated into Federal Way School District 210. All students moved into the newly built Federal Way School, shown here in 1935. The district was named Federal Way for the newly established federal highway that abutted or crossed each of the five previous districts. This highway is now called Pacific Highway South. (Courtesy Carol Cox.)

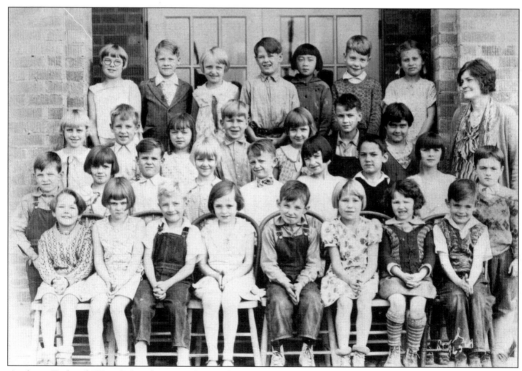

At first, Federal Way School was only an elementary school for grades one through eight. Pictured here are 1930–1931 first and second graders with their teacher, Hanna Holmstrom. (Courtesy Carol Cox.)

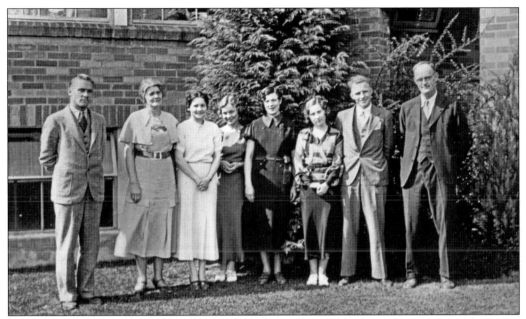

This is the 1935–1936 Federal Way School faculty in front of the school with principal Charles Springer (second from right). In 1937, the high school opened in an expanded building, with the first class graduating in 1939. The high school still occupies this building, although additions and remodeling have changed the appearance both inside and out. There are now four additional high schools in School District 210. (Courtesy Carol Cox.)

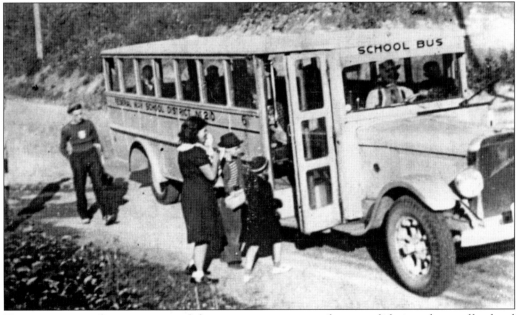

Transporting students was one of the motivating reasons for consolidating the small school districts into one large district. Funds could be pooled to provide buses and eliminate the need for students to walk long distances. This 1930s photograph shows school bus driver Ed Sutherland picking up students for Federal Way School. Most of the roads at that time were gravel or dirt. (Courtesy Marie Reed.)

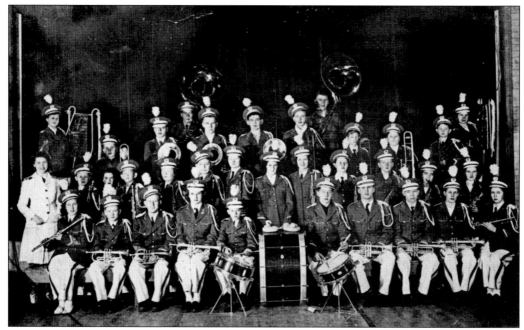

The Federal Way High School Band was organized in 1939. For the first 10 years or so, the high school band also included elementary school students, as seen in this 1946–1947 photograph. The PTA provided the funds for the uniforms, even though they did not all match. At least one band member did not have a uniform. The band played mostly classical music. (Courtesy JoAnn Desch Svengard.)

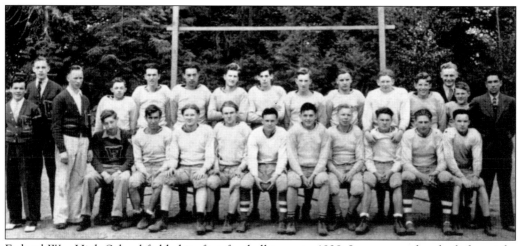

Federal Way High School fielded its first football team in 1938. It was considered a lightweight team (junior varsity). That team won two games. Assistant coach George Cronquist (back, third from right), the social sciences and math teacher, and head coach Merton Poole (back, far right), social sciences and athletics teacher, led the team. (Courtesy 1939 seniors of Federal Way High School.)

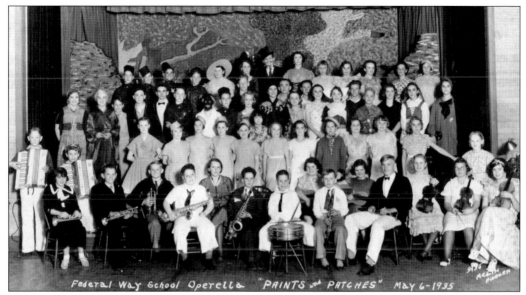

Seen here is the cast of the Federal Way School 1935 operetta *Paints and Patches*. Since the high school had not opened yet, these were all elementary school students. In the first 20 years of Federal Way elementary and high school operations, the PTA provided the money for most extracurricular activities, band uniforms, and school lunches. (Courtesy Carol Cox.)

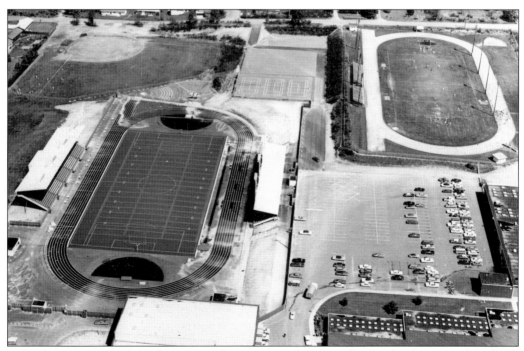

Federal Way Memorial Stadium opened in 1971 on the grounds of Federal Way High School. Federal Way High School, Decatur High School, Todd Beamer High School, and Thomas Jefferson High School still use it for football games and track meets.

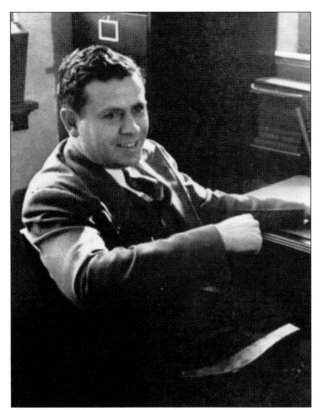

Kenneth Jones was a major factor in the development of the Federal Way School District. He started as a teacher in 1938, became principal of Federal Way High School in 1939, and in 1940 became superintendent of the district, a post he held until retirement in 1966. In 1971, a new King County swimming pool was opened near the school and named the Kenneth Jones Pool.

The school district operated with only one school for first grade through high school until a major school building program was started in the 1950s. The first new school was Lakeland Elementary, opening in 1952. Lakota Junior High, built in 1960, is shown in this 1968 photograph. By 2007, the Federal Way School District had 37 schools, 22,178 students, and 2,700 staff members. (Courtesy Federal Way School District 210.)

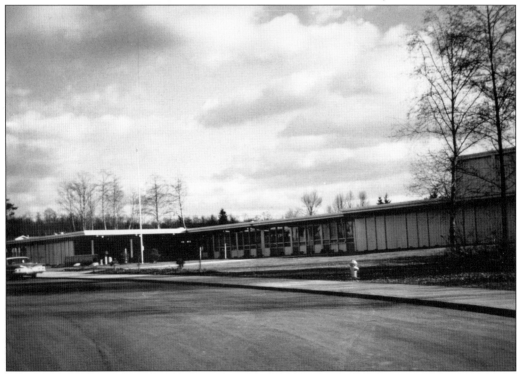

# Four

# PEOPLE

The first non–Native Americans to visit the area were mainly loggers who used the easy water access point around Poverty Bay. Many stayed only a short time. Zacharias Stone and his family came to the Poverty Bay area in 1869 but did not build a permanent residence. Many people started to settle in the area in the 1870s, but only a few of the names are known and photographs are sparse. The first known permanent settler in the area was Ernst Ferdinand Lange, who built a cabin on the beach area of what is now Redondo. Sam Stone, evidently encouraged by what Zacharias Stone had seen, established a homestead claim near Stone's Landing (the Redondo beach area) in 1871. By the end of the decade, homesteaders were settling around Star Lake, Mirror Lake, Steel Lake, and in the North Edgewood area as well. By the late 1880s, there were 50 homestead claims for the overall area.

These early settlers were law-abiding, hardworking people. They had to work hard for what little they had. They soon found that they couldn't raise much on the highland glacial soil.

In 1882, Mr. and Mrs. William Mears became the first residents of the Brooklake area. In 1883, John Barker was among many who were filing homestead claims. He built his first home that year on his claim east of Mirror Lake. Theodore Taylor Webb and his wife, Jane Cuddy Webb, came to the Harding District in 1884 and filed a homestead claim.

Arthur Steele settled in the area around the lake that would bear his name in the 1880s. The final "e" was dropped from the name, Steel Lake, in the 1940s, although family members living in the area still retained the final "e" into the 1970s.

In the 1880s, Philip French built a home and lumber mill on what was then referred to as French Lake. This is now known as Mirror Lake.

Many of the early settlers' families continued to reside in the area and were essential to the development of the area for two or three generations.

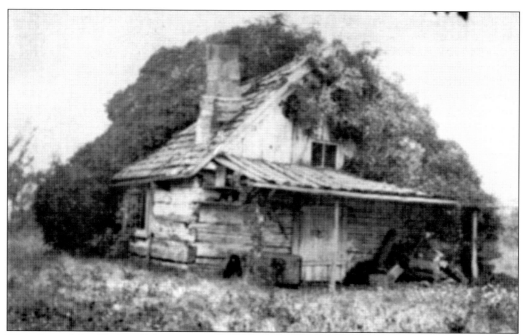

This shot of the Barker Cabin is an example of the simple architecture of the homes built by the first settlers of the area. John Barker constructed this 16-foot-by-16-foot horizontal hewn-log cabin with a partial loft in 1883. Barker, his wife, and three children lived in it until 1890. It still exists in a restored state at West Hylebos Wetlands Park.

The Barker Cabin was originally located near what is now Seventh Avenue South just south of South 312th Street. Barker filed for a 160-acre homestead claim and developed the claim as required. He received the ownership patent shown here on June 28, 1890. Barker was active in early road development, in forming an early school district, and in developing large holdings of land beyond his homestead claim. (Courtesy Claude Barker.)

In 1885, African American pioneers John and Mary Conna settled on a 157-acre homestead at the southeast side of Panther Lake near the present location of the Weyerhaeuser King County Aquatic Center. Conna was a Civil War veteran. He was appointed assistant sergeant at arms of the 1889 Washington Territorial House of Representatives. Conna and his family moved to Tacoma before getting rights to the homestead claim. (Courtesy Douglas Barnett.)

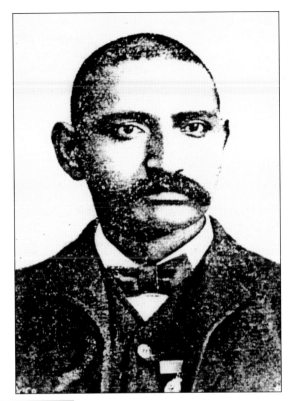

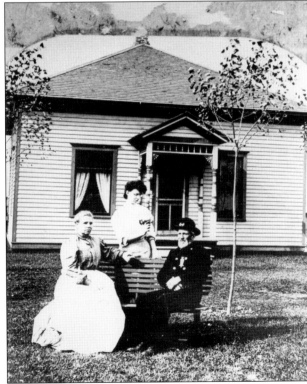

This is a photograph of Civil War veteran James Henry Duncan and his wife, Larrenza (left), at a Civil War remembrance in Seattle around 1890. Duncan purchased land in Federal Way in 1887. He built a house at what is now Twenty-eighth Avenue South and South 370th Street in what was then called North Edgewood. The house burned down but was later rebuilt. (Courtesy Ruth Duncan Ritter.)

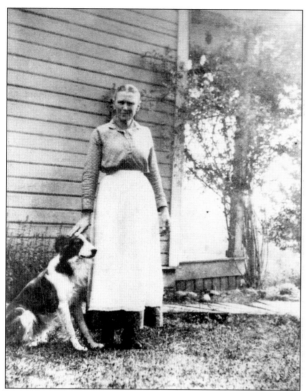

James Henry Duncan subdivided and sold most of his 80 acres between 1888 and 1895. The properties became flourishing small farms that developed into Hinkle's Corner. Duncan died in 1912, but his wife, Larrenza, continued the development of the area until she died in 1938. Larrenza and her dog Shep are pictured here in 1910 beside the house that was rebuilt. (Courtesy Ruth Duncan Ritter.)

Henry Bucey was a colorful, energetic person who had dreams for a community that would eventually be called Buenna. He was a man who planned roads, railroads, and a town. He cared about and helped all the people who began to live in the area. He was a farmer, nurseryman, town father, and promoter of a railroad that wasn't built. Bucey (seated) is shown in his law office about 1925. (Courtesy Helen Bucey.)

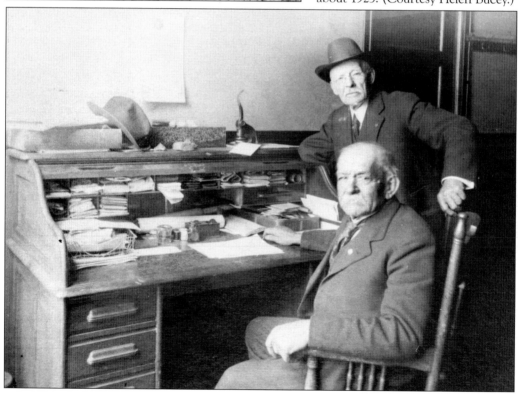

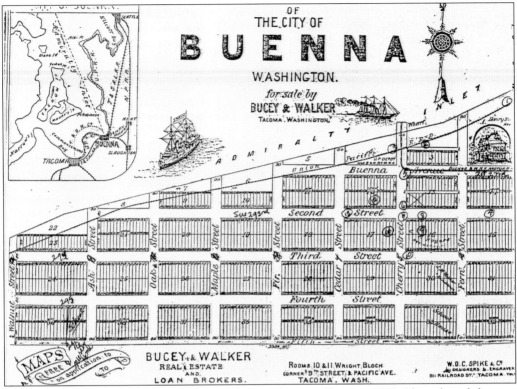

Henry Bucey and L. F. Rodgers purchased about 180 acres of land in 1892. They platted the area to develop the town of Buenna. Southwest 292nd Street, Second Avenue Southwest, Southwest 296th Street, and Seventh Avenue Southwest currently border the property. The Panic of 1893 intervened in the development, and finances for the project disappeared. The sketch is from about 1893.

The Henry Bucey family is shown about 1905. Posing from left to right are (front row) Henry, Nellie, and Herold; (back row) Gerald and Marion. When Henry and Nellie were about to plat the land they had just purchased, they were sitting at a family meal discussing what to name the new town. Baby Harold, who could not say many words yet, began to point and call for a banana. But it came out "bu-en-a." (Courtesy Helen Bucey.)

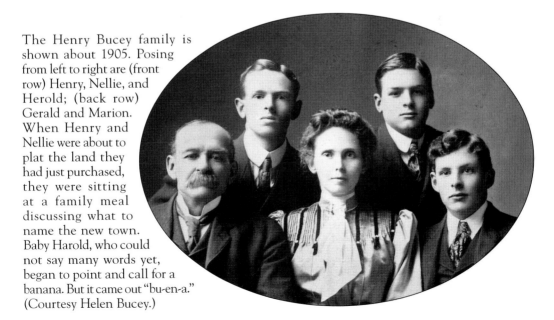

Marquis Lafayette (L. F.) Rogers poses around 1900. Rogers and his wife, Mildred, came to the area in 1891, as most early visitors and settlers did, by a steamer from Tacoma to Stone's Landing. He opened a sawmill as the area was being logged for development and had easy access to water transportation. He became an equal owner with Bucey in the town site of Buenna. (Courtesy Dorothy Rogers.)

L. F. Rogers built this house in 1891, and this photograph was taken shortly after its construction. It is representative of the homes planned for Buenna. It still exists at 305 Southwest 293rd Street, although it has undergone much remodeling. (Courtesy Dorothy Rogers.)

Taylor and Jane Webb moved into the North Edgewood area in 1884 and filed a homestead claim. In 1890, they purchased 120 acres of land that is now directly east of Pacific Highway South between South 312th Street and South 326th Street. They soon moved to the south 40 acres of their recently purchased land and sold the rest. Shown is Jane Webb around 1930. (Courtesy Shirley Charnell.)

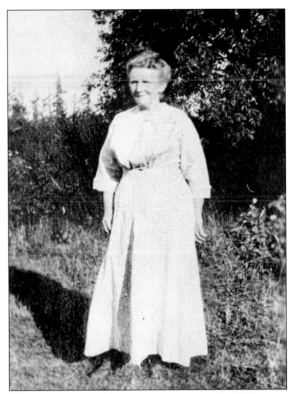

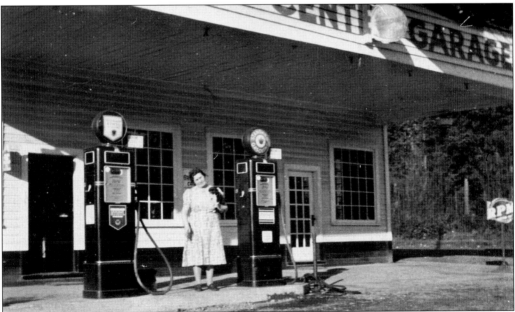

Andrew Kristensen settled on 40 acres on the southwest side of the present intersection of South 320th Street and Pacific Highway South. In 1933, he built a garage and gas station called the Webb Center Garage, since he was a friend of Webb's. The term Webb Center was used on maps of this area for many years. Pictured are Edith Kristensen and dog Midget around 1938. (Courtesy Shirley Charnell.)

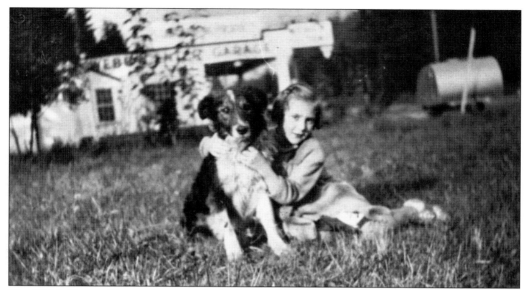

The Webb Center Garage shown in the background is where the Bank of America branch is now located. Also shown is Shirley Charnell, granddaughter of the Kristensens, and her dog Bingo, around 1942. As an adult, Charnell was active in area politics, the chamber of commerce, and in preserving the history of the area. (Courtesy Shirley Charnell.)

Taylor Webb raised cattle and farmed his land. He was instrumental in forming the Steel Lake School District 92 in 1891. Mabel Webb Alexander, daughter of Taylor and Jane Webb, stands in front of the family home in the late 1950s. This house was demolished to make way for SeaTac Mall in the mid-1970s. (Courtesy Marie Reed.)

Mabel Webb Alexander (right) poses with her daughter Carolee Johnson at the northwest corner of the land they used to own. The land behind them was cleared in the mid-1970s to make room for SeaTac Mall, now known as the Commons at Federal Way. This area was once known as Webb Center and is now part of the city center of Federal Way. (Courtesy Shirley Charnell.)

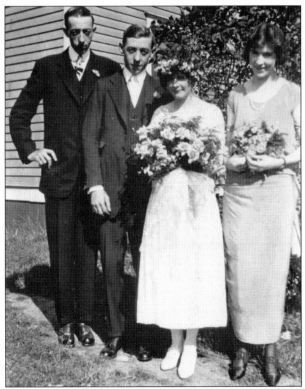

In 1918, four brothers from Leavenworth, Kansas—Oscar, Arthur, Charles, and Theodore Cruse—purchased adjoining properties, which totaled 40 acres, on South 280th Street in the Star Lake community. In the 1930s, Art became a leading member of the school board of the new Federal Way School District. Shown in this 1923 wedding photograph from left to right are Charles; the groom, Theodore; the bride, Ethel Downing; and her best friend, Helen Hefferon. (Courtesy Marie Reed.)

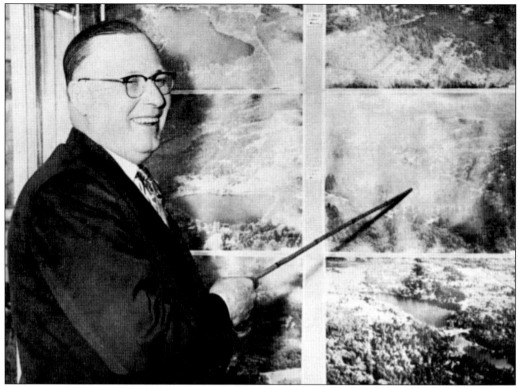

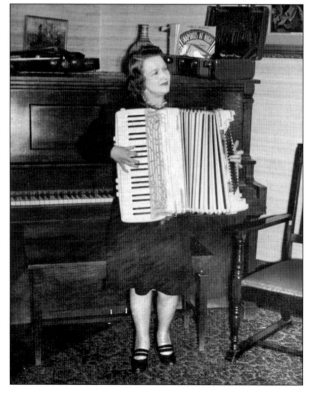

In 1948, C. Ralph Fleming opened the first real estate office in Federal Way. His efforts led to much of the housing development in the area, including Marine View Estates, Steel Lake Terrace, and Soundcrest Homes. This 1955 photograph shows Fleming pointing to available lots around Steel Lake. Both Ralph and his wife, Nellie, were active in most of the local community organizations. He died in 1965. (Courtesy Evelyn Cissna.)

Ralph Fleming was also active in the development of Federal Shopping Way. Nellie Fleming operated the real estate office until it was closed in 1984 after the bookkeeper embezzled $60,000. She played several musical instruments for various activities and clubs and purchased an organ for use in her travel trailer. Fleming is seen here with her accordion in the 1950s. She died in 1995. (Courtesy Dicci Dillon.)

This is Ilene and Francis Marckx in 1955. They first came to the area in 1944 and opened a farm store at Pacific Highway South and South 312th Street. Francis Marckx helped develop the area's first large subdivision, Soundcrest Homes, in 1952. The couple also owned land eventually donated to the state for a park. This is now the 120-acre West Hylebos Wetlands Park, owned by the city. (Courtesy Ilene Marckx.)

Pictured are members of the 1958 Greater Federal Way Chamber of Commerce, including Harold Lundstrom (back center), Francis Marckx (back right), and Phil Eichholtz (first row, right). In 1945, Lundstrom's Market opened on the north side of South 312th Street along Pacific Highway South. This was the main grocery store for many years. In 1954, Eichholtz opened the still-operating New Lumber and Hardware Company at 30854 Pacific Highway South. (Courtesy Jim Eichholtz.)

In 1951, Bertold Bruell became the first doctor to set up a permanent practice in Federal Way. Bruell said he came to Federal Way because "there was a need for a physician, and I wanted to be a country doctor and have a country practice." This photograph shows Bruell and his family in 1951. He retired in 1989. (Courtesy Edith Bruell.)

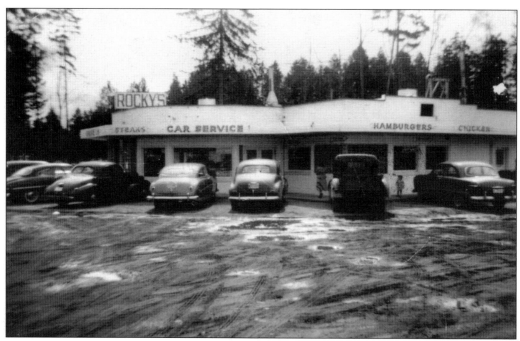

In 1948, Rocky Rockwell opened Rocky's Drive-In Restaurant at 31815 Pacific Highway South. This was one of the first restaurants where waitresses would come out to the car, take an order, and then bring back the food. When first opened, this was one of a half-dozen businesses operating in Federal Way. In 1960, Rockwell opened his second Federal Way business, Secoma Lanes Bowling Alley. (Courtesy Rocky Rockwell.)

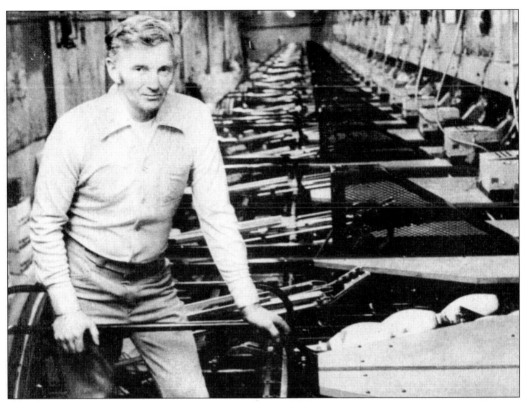

Secoma Lanes was a state-of-the-art bowling alley with 24 lanes and automatic pinsetters. Shown here is Rockwell in 1979 in the automated pin-setting area. The bowling alley still operates under his management. Rockwell was a longtime commissioner for the Lakehaven Sewer District and helped start the local chamber of commerce, Kiwanis, Toastmasters, and various other community groups. (Courtesy *Federal Way News*.)

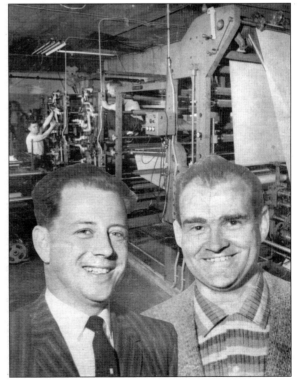

In 1955, the *Federal Way News* published its first edition to become the first full-sized newspaper to broadly cover the Federal Way area. This 1958 photograph shows Al Sneed (left) and Jerry Robinson, joint owners of the paper through 1963, when Robinson acquired it. Robinson always stated, "The only reason for our existence is the need for a local approach to news coverage." (Courtesy Washington Newspaper Publishers Association.)

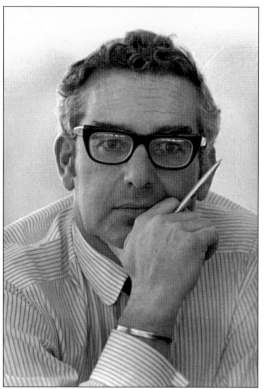

Frederick Weyerhaeuser and 15 partners bought timberland in western Washington in 1900. The purchase included extensive holdings in Federal Way. Over the years, the land was sold to others who did the logging. In the 1970s, George Weyerhaeuser, president of the Weyerhaeuser Company, was instrumental in bringing the Weyerhaeuser Corporate Headquarters and Technology Center to Federal Way. He is shown here in the early 1970s. (Courtesy Weyerhaeuser Archives.)

The Weyerhaeuser Corporate Headquarters Building is pictured shortly after it opened in 1971. Mount Rainier is in the background. In 1974, the company began developing the area west of Pacific Highway South. This West Campus development added 125 new businesses and several hundred homes, apartments, and condominiums. The Weyerhaeuser Company currently has about 3,000 employees in the Federal Way area. (Courtesy Weyerhaeuser Archives.)

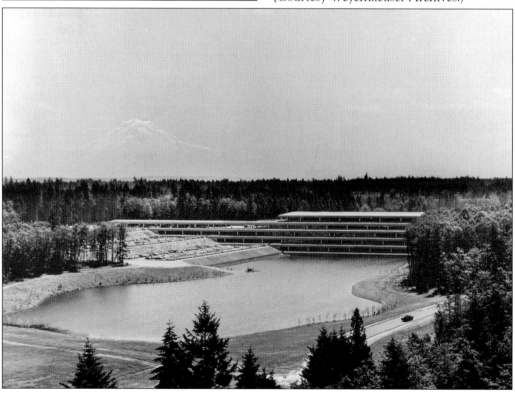

# Five

# TRANSPORTATION AND SERVICES

There were no roads, only trails, in the mid-1800s when loggers made their way to what would become Federal Way. It wasn't long before all that changed. The first road built in the area was named Military Road because it was needed to transport supplies between Fort Steilacoom and Fort Lawton. The section between Seattle and Pierce County was completed in 1860.

By the end of the 1800s and into the early 1900s, loggers and settlers began building roads for their own purposes. Many of these rutted paths, some with embedded logs, eventually became well-traveled thoroughfares.

The Seattle/Tacoma Interurban Railway became a popular means of travel from 1902 to 1928. The train hugged the west valley, connecting to both Military Road and Pacific Highway South by major routes. It not only helped farmers get their produce to market, but it also encouraged settlers to populate the area.

About 1910, civic leaders decided to encourage economic growth by building a road from Canada to Mexico. Called US-99, it was designated a first-generation interstate in 1925 and was thus eligible for federal funds. US-99 (eventually called Pacific Highway South) was finally paved between Seattle and Tacoma in 1930.

The Great Depression, followed by World War II, practically ensured that Federal Way remained rural. Settlers gradually moved in, but there was little economic progress. There were few services, with the exception of a telegraph wire that was introduced along Military Road in 1864. By the early 1920s and into the 1940s, water and electric services were introduced. A number of volunteer fire departments formed to safeguard the many small communities that eventually became Federal Way. Local utilities included a water district, gas and electric services, and an updated telephone system by the early 1950s.

People had little trouble finding Federal Way by the 1970s. Interstate 5 opened and through the years was upgraded to eight lanes. There was access to the valley (State Route 167) from various locations, and South 348th Street became a major east-west route to Interstate 5, State Route 18, and Interstate 90. Federal Way was on its way to becoming a city of more than 88,000 people.

Skid or "corduroy" roads, like the one near Sixth Avenue Southwest, preceded roads that became major thoroughfares in Federal Way. A good example is Reith Road that intersects Pacific Highway South and South 260th Street. In the 1880s, Jacob Reith logged timber from a timber claim and then built a skid road 100 feet west to transport his logs to the water. (Courtesy Marie Reed.)

This map shows how street names have changed since Federal Way's infancy. Streets once named for people who built the roads or lived nearby are now numbered or given new names. For example, South 312th Street was called Phillip French Road, Dash Point Road was called Maltby Road, and Cole's Corner is South 312th Street and Pacific Highway South. Most names were changed by 1956. (Illustration by Lee Helck.)

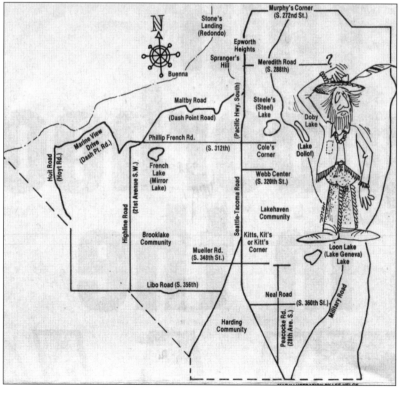

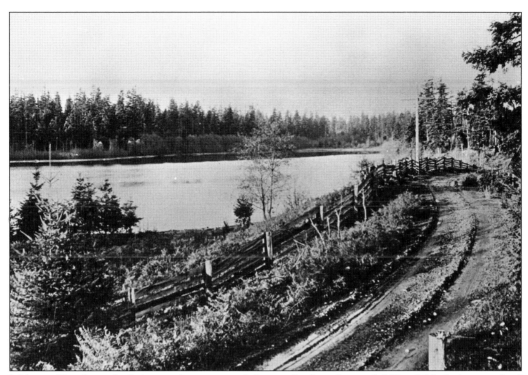

Military Road was little more than a rutted dirt path along beautiful Five Mile Lake, south of South 360th Street, when photographed here in the late 1800s. It was the first main road in Federal Way. Volunteers began surveying and clearing the road in 1853 prior to the Civil War. Congress appropriated $35,000 to construct the road in 1857. By 1860, it was complete between Seattle and Pierce County. (Courtesy Museum of History and Industry.)

The road at Redondo had been built but not paved in 1922 when these young men in their Buick stopped in the sandy, rutted road next to the beach. Pilings in the background were near the end of a skid road that terminated at Coldbrook Park, currently known as Redondo Shores. The pilings were probably used to raft logs, which would be towed to nearby mills. (Courtesy JoAnne C. Thompson.)

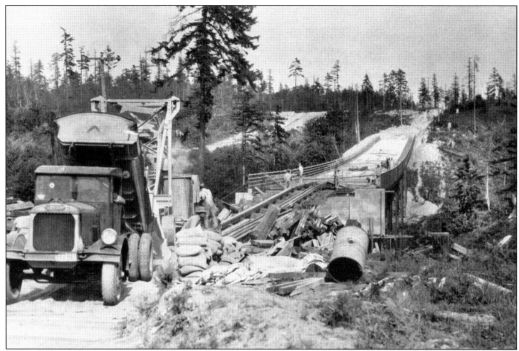

In this 1933 photograph, workers use a dump truck and concrete to build the Marine View Highway Bridge. It is located near Dash Point State Park. The bridge was part of the scenic highway from Blaine (at the Canadian border) to Olympia (the state capital) via the Eleventh Street Bridge in Tacoma. (Courtesy Frank Werdenhoff.)

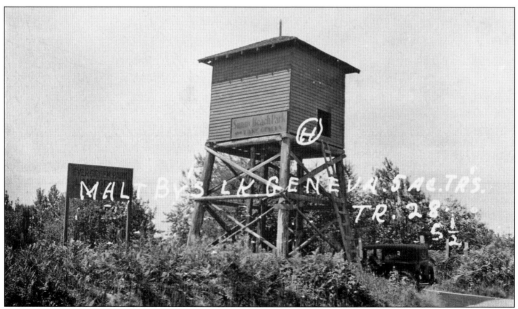

A wooden water tower on log poles is part of Maltby's Lake Geneva 5-acre tracts at South 344th Street and Military Road in 1938. (Courtesy Washington State Archives, Puget Sound branch.)

Fir trees and little else line the road near Pacific Highway South and South 336th Street in April 1939. Heading north, a car is passing the recently rebuilt Green Parrot Inn (on the left). In the distance is the cutoff to Puyallup, now South Sixteenth Avenue. (Courtesy Helen Clinkinbeard.)

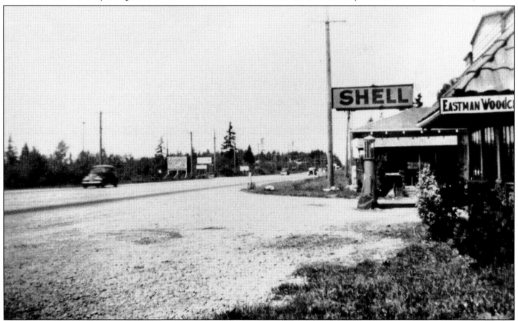

In 1941, Federal Way looked rural and not congested with few businesses north of Pacific Highway South and South 314th Street. To the right is Harold Hagen's home and gas station, next to Eastman Woodcraft. (Courtesy Carol Hagen Dooley.)

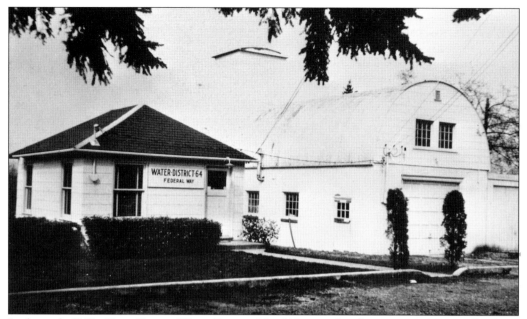

In the early 1940s, King County Water District No. 64 began absorbing many of the smaller local water districts, like Steel Lake and Northland Cooperative. The oldest utility in the area was District No. 56. In 1939, it was comprised of Buenna and Redondo and was owned by Weston Betts. Eventually all the water districts merged to form Lakehaven Utility District, which now serves the Greater Federal Way area. (Courtesy Water District No. 64.)

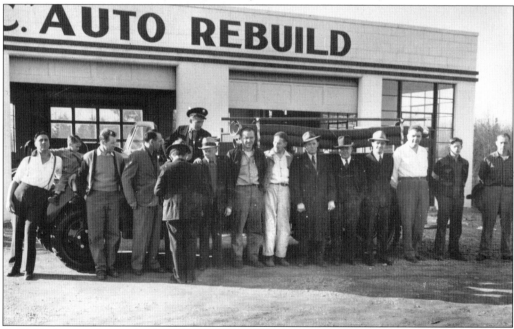

A 1940s fire truck is parked in 1946 in front of the A.B.C. Auto Rebuild garage on the west side of Pacific Highway South, north of South 310th Street. Among those pictured are Harold Lundstrom of Lundstrom's Market and Al Content, owner of the garage. Content and his family lived on the premises. (Courtesy Rene Content.)

A Steel Lake water tower is pictured in the 1940s. Steel Lake was one of a number of small communities within the area that had its own water district. Initially, homesteaders used lake water and their own wells for drinking water. (Courtesy Ila Mae March.)

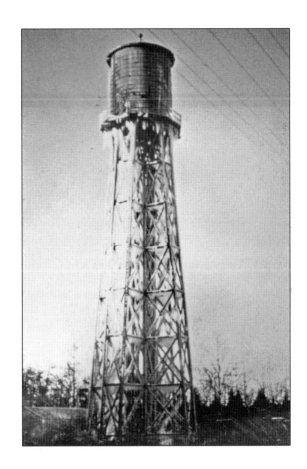

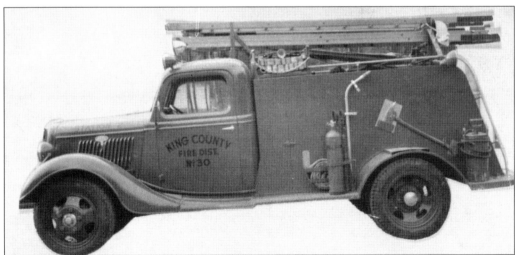

Star Lake's King County Fire District No. 30 purchased this 1935 Ford truck with fire hoses in 1947 after a fund-raising benefit. Volunteers organized the fire district in 1946 after three neighborhood homes were destroyed by fire in 1945. Howard Conner donated property for the firehouse and served as the first fire chief. Fire District No. 20 merged with Fire District No. 39 in 1980. (Courtesy Luella Hilby.)

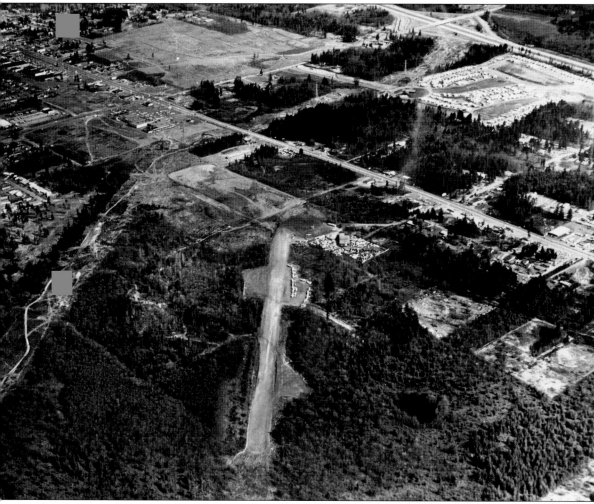

The Evergreen Air Park, seen here in the lower half of this 1965 photograph, started out as a pig farm west of Pacific Highway South and South 330th Street. The farmer cleared a landing strip in about 1938 and then opened for business in 1941. Walter Ostendorf and other Boeing employees purchased the property in 1946. Construction of the airstrip began in 1948, and by 1954 it was 100 feet wide and 2,300 feet long and owned by 60 shareholders. The site also had hangars and living facilities. Gasoline was purchased on the honor system. The City of Federal Way bought the 83.5-acre property in 1990 for about $12.5 million to build Celebration Park. (Courtesy Martin Johnson.)

The Miller Oil Service truck was one of the first trucks to deliver oil in the area in 1948. (Courtesy Ilene Marckx.)

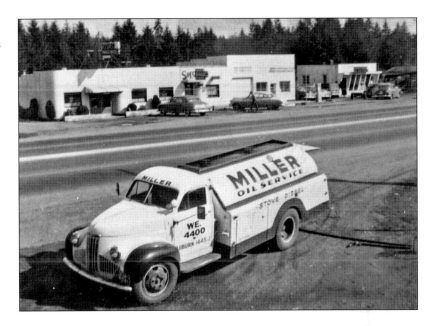

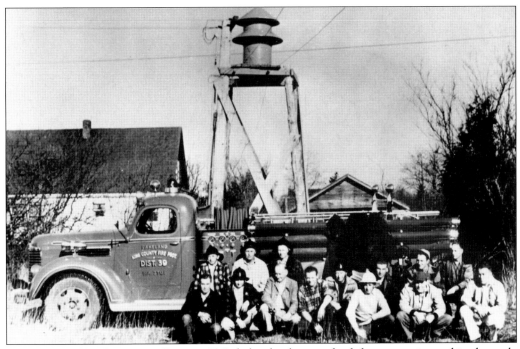

King County Fire Protection District 39 Lakeland volunteer firefighters are pictured in the early 1950s with their fire truck. Formed in 1949, the district purchased an International 500-gallon-per-minute pumper in 1950. It was stored in Jim Hardy's barn at South 368th Street and about Thirtieth Avenue South until a fire station was built in 1953. Various fire districts eventually merged to form Federal Way Fire District 39.

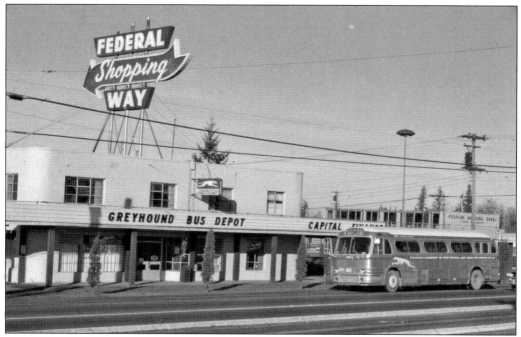

A Greyhound bus depot just south of Pacific Highway South and South 312th Street was a regular stop for many riders in the 1950s. The bus transported people between Seattle and Tacoma along Pacific Highway South. One local pioneer, who frequently traveled with her mother to Tacoma, remembered Greyhound had 10–15 drivers during the mid-1930s who knew most of their regular customers by name. (Courtesy Evelyn Cissna.)

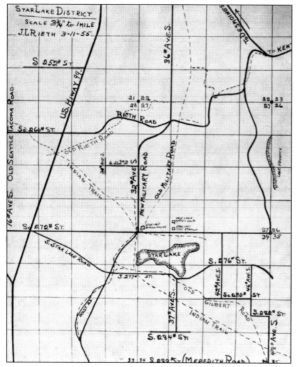

This 1955 map by J. L. Reith shows the many changes that have occurred in the Star Lake area between South 240th Street to the north and South 288th Street (Meredith Road) to the south. New and revised roads are pictured as solid black lines; dotted lines refer to the paths of original roads. (Courtesy Star Lake Improvement Club.)

The People's National Bank donated its temporary bank building to the Federal Way Library trustees in 1961, providing needed space for an increasingly popular local library. J. R. Cissna offered space for the library at the southwest corner of the Federal Shopping Way near Pacific Highway South and South 312th Street. Volunteers donated time and energy, building a foundation and providing materials for $750.

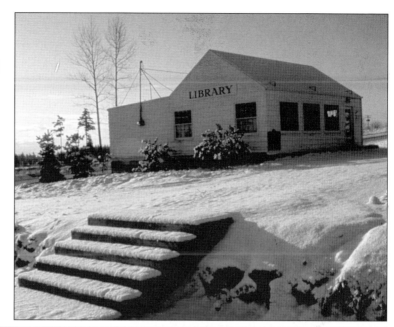

The Evergreen Truck Stop, pictured on the corner of South 348th Street and Sixteenth Avenue South across from a future Costco, opened in 1969. Doug Clerget bought and developed the land, anticipating Highway 18 would connect Interstate 90 and Interstate 5. The truck stop included a Chevron station, Gee-Gee's Restaurant, a motel, and truck repair. A shopping center called Federal Way Crossings replaced the truck stop in 2007.

The headquarters for Federal Way Fire District No. 39 at 31617 First Avenue South was completed and dedicated in May 1979. By the mid-1970s, the fire department was averaging 70 calls a month, and had a paid chief, 100 paid and volunteer firefighters, and four full-time locations. (Courtesy Marie Reed.)

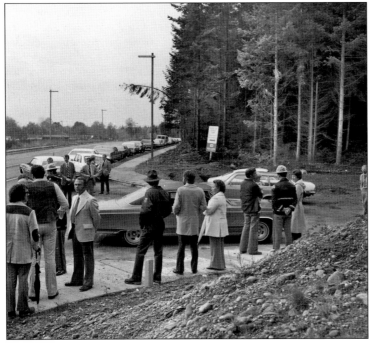

Residents await the official ground-breaking ceremonies for the new Federal Way Municipal Court on October 29, 1977, at 33325 Eighth Avenue South. Robert E. Stead was Federal Way's first district judge in 1965. (Courtesy Marie Reed.)

# Six

# EARLY BUSINESSES

Settlers moved west toward what is now Federal Way in the late 1800s. Many sought work in the logging industry and on fertile land to farm. But they needed supplies.

By the late 1800s, the first settlers put down roots in Stone's Landing. Logging was good, and supplies were easily sent by steamships serving Puget Sound. Federal Way's first store was built near the beach in about 1904. Restaurants, dance halls, real estate promoters, and a post office soon followed.

The increased use of vehicles in the early 1900s meant people were on the move, traveling not only by horseback, buggy, or boat, but by car between Seattle and Tacoma. Businesses popped up along busy roadways like Pacific Highway South, Military Road, and along side roads like South 320th and South 356th Streets. Gas stations, restaurants, inns, and taverns became opportunities for travelers to purchase supplies or take a break.

One of the earliest of these eateries was the Wagon Wheel Restaurant, located west of 356th and Pacific Highway South. Built in 1920, it was located at the site of the current Brooklake Community Center. Through the years, it was used as a speakeasy, gambling den, and brothel. Half a mile north at Pacific Highway South and 348th Street was the Coffee Cup Tavern. Initially a fruit stand, it later became a popular tavern. Early grocery stores opened in 1911 just north of South 256th Street and South Sixteenth Avenue and at Redondo Heights at South 279th Street and Pacific Highway South.

By the end of the Depression and World War II, people seemed more willing to tackle new ventures. Businesses opened in rapid succession over the next 40 years. Caucasian, Asian, and Hispanic restaurants were intermingled with shopping areas like the Federal Shopping Way and Secoma Village, drugstores, a truck stop, motels, meat market, grocery stores, real estate offices, and physicians' offices. Dr. Bertold Bruell became Federal Way's first doctor in 1951, followed in 1954 by Dr. Robert Lundeen. The covered SeaTac Mall, now the Commons at Federal Way, opened to thousands of shoppers in 1975.

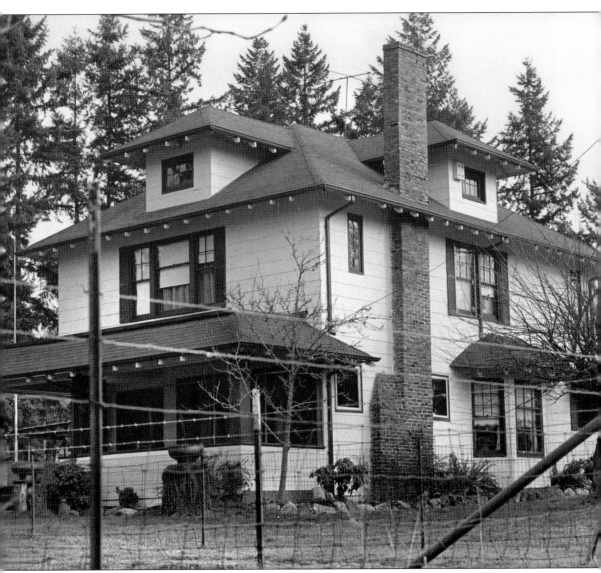

In 1910, the Jovita Land Company built a model home at 4600 South 364th Street to attract buyers to the area and promote the Interurban Railway. It was in one of the first area subdivisions in one of the largest platted areas in South King County. The house was sold in a raffle. Winners Ruben and Dora Corbett purchased the winning ticket for $25 at a Five Mile Lake promotional event and lived there for many years. Jovita Land Company owner C. A. Stokes started the company in 1908, naming it after his granddaughter. But he was forced to liquidate his assets after being arrested in 1909 for transporting liquor to Alaska. His company was transferred to shareholders and put in his wife's name for $10. Still in excellent condition, the house was designated a King County landmark in 2003.

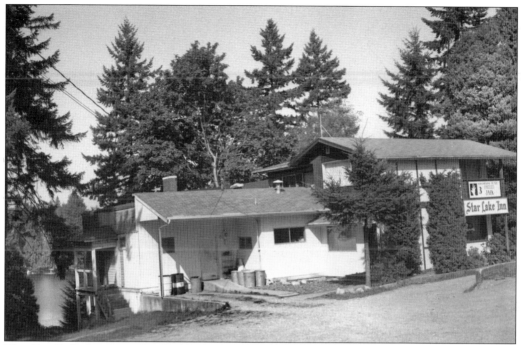

The Star Lake Inn at 3419 South Star Lake Road, pictured here recently, was built in the late 1800s. Charles and Hattie Hanemann purchased the property about 1918 and operated it as a resort until retiring in 1951. Their son Ovid and his wife, Jean, continued the business as a store and resort until it was sold in 1969. The property is currently a tavern. (Courtesy Marie Reed.)

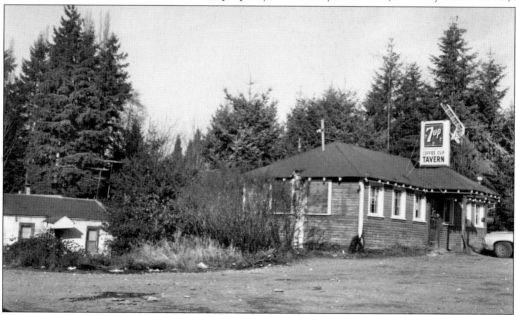

The Coffee Cup Tavern was a popular place for more than 50 years for beer drinkers who enjoyed country music, the jukebox, pinball machines, and pool tables. Built in the mid-1920s as a fruit stand, it was converted to a tavern in the 1930s. It was located just south of South 348th Street and Pacific Highway South. The building was destroyed by fire in 1980. (Courtesy Marie Reed.)

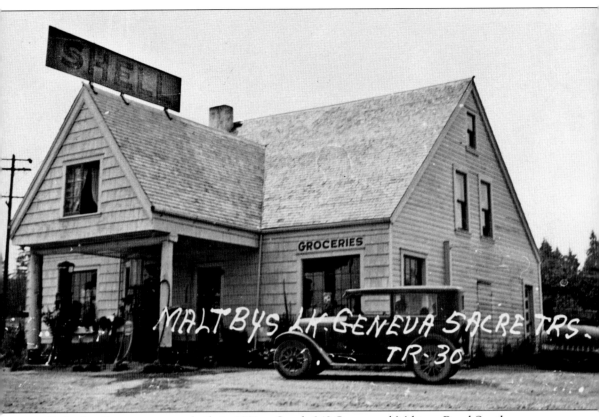

Sutherland's grocery store, built in 1931 at South 342 Street and Military Road South, was one of only four grocery stores in Federal Way and Redondo. Victor Sutherland, who immigrated to the area with his family in 1912, built the store to sell groceries, seasonal produce, and milk. In 1934, he contracted with the Shell Oil Company to sell gas. Ideally located near Lake Geneva and on a busy road, the store served travelers and an increasing population. After Sutherland died in 1944, his widow, Ida, and his brother Alfred managed the business until 1947. Victor's son Lloyd operated the store until 1953, when he sold it to Roy and Florence Blackburn. The Blackburns ran the store as the Lake Geneva Grocery Store until 1984. The building is now a King County landmark. This photograph was taken in the late 1930s. (Courtesy Washington State Archives, Puget Sound branch.)

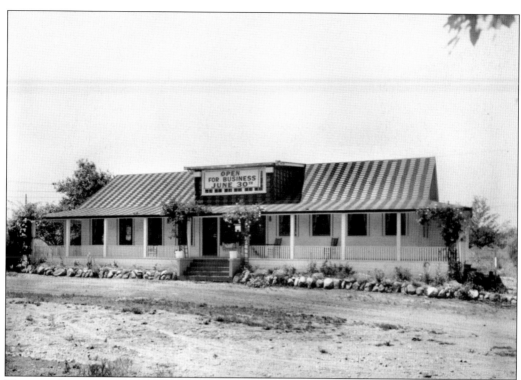

The grand opening of Rose's Hi-Way Inn, at 29616 Pacific Highway South, occurred on June 30, 1939. Though owners Rose Wilcox and her sister Sarah served steak and seafood, they specialized in fried chicken dinners with all the trimmings at 75¢ a plate. The chickens were originally raised behind the restaurant. The restaurant was sold to Lila Hudson in 1967. It was destroyed by fire in 2002. (Courtesy Tacoma Public Library, Richards Studio A8483-1.)

Located along Pacific Highway South and South 336th Street, the Green Parrot Inn was the most well-known restaurant in the area in the 1940s. Waitresses served five-course family meals for $2.50. The building was constructed in 1924 and in 1940 was owned and operated by John and Myrtle Gates. It stayed open throughout World War II. It was replaced by a professional office building in 1979. (Courtesy John S. Gates.)

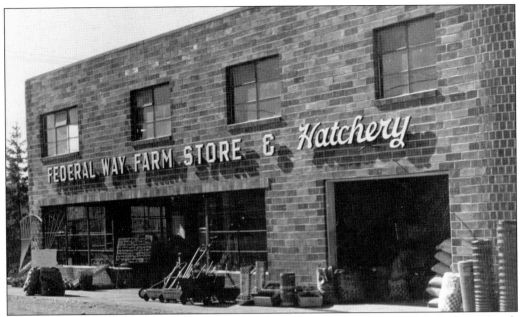

The Federal Way Farm Store and Hatchery at South 312th Street and Pacific Highway South featured farm and garden supplies when it opened in 1944. Owners Francis and Ilene Marckx also held feeding demonstrations for calves, pigs, rabbits, puppies, and baby chickens. The Marckxes doubled the size of the building in 1947 and then sold it in 1953 to Federal Old Line Insurance for the Federal Shopping Way. (Courtesy Ilene Marckx.)

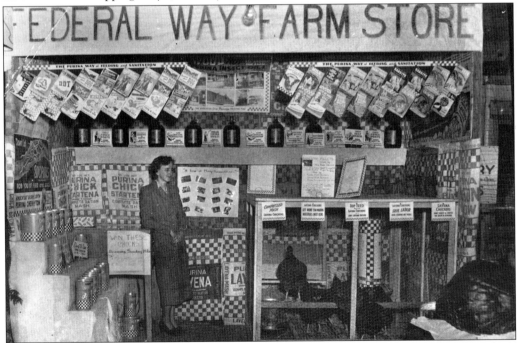

Ilene Marckx promotes her store at a booth at the Brooklake Fair in the mid-1940s. The Marckxes sold farm and garden supplies to help wartime customers raise meat and vegetables during hard times. (Courtesy Ilene Marckx.)

Early business owners Ben and Juve Robertson sold toys from a small trailer at Pacific Highway South and South 332nd Street in 1945. (Courtesy Ben Robertson.)

In subsequent years, the couple expanded their business and renamed it Robertson's Pottery, Gifts, and Novelties, where they sold merchandise both wholesale and retail. Robertson also operated a long-haul shipping firm and sold limousines and antique car parts prior to starting Robertson's Antique Cars at 34627 Sixteenth Avenue South in the early 1970s. (Courtesy Ben Robertson.)

Built around 1938, the Blue Jay Grill near Pacific Highway South and South 288th Street overlooked Puget Sound and was a popular hamburger hangout for teenagers and young adults in the 1940s and 1950s. The grill is pictured in the late 1950s. Robert and Ruth Miller operated the restaurant for 19 years prior to selling it to Arthur and Mary Anderson of Seattle in 1955. (Courtesy Mike Anderson.)

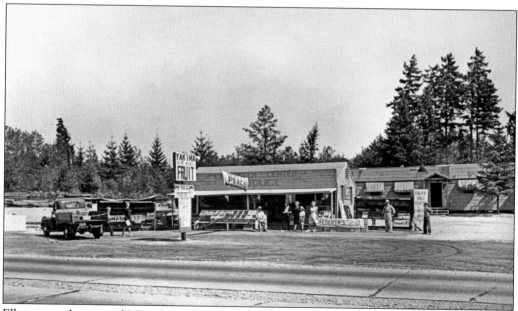

Elberta peaches were $2.72 a box in 1945 when Vern and Vera Frease sold Yakima produce at their business at South 333rd Street and Pacific Highway South. The couple used army barracks for both the business and their housing. Two years later, they replaced the barracks with a store, which they operated for one year prior to leasing it to new managers. The business area is now called Secoma Village. (Courtesy Wendal Kuecker.)

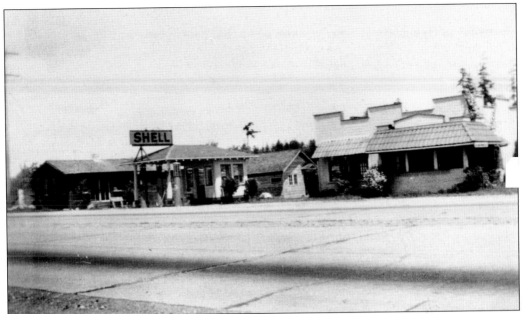

An early-1940s photograph shows property called the Federal Way Shopping Intersection on the east side of Pacific Highway South near South 314th Street. Within a few years, the building on the far left became Pauline's Tavern and the Federal Way Variety Store. To the right of the gas station is Eastman Woodcraft, which made myrtle wood souvenirs and mahogany candy boxes for Brown and Haley. (Courtesy Carol Hagen Dooley.)

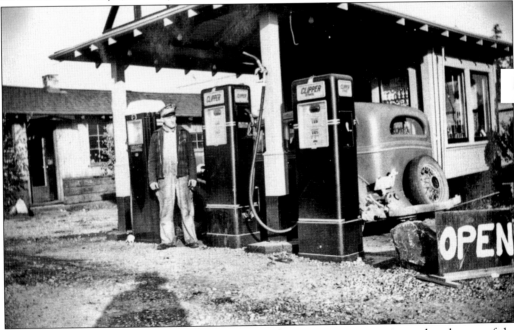

Service station owner Herold Hagen, seen here at the same gas station pictured at the top of the page but now with updated pumps, served Clipper gas as opposed to Shell gas. The pump indicates Hagen pumped six gallons of (ethyl) premium gas for 22¢ per gallon for a total of $1.32. This gas station was one of the first in Federal Way. (Courtesy Ila Mae March.)

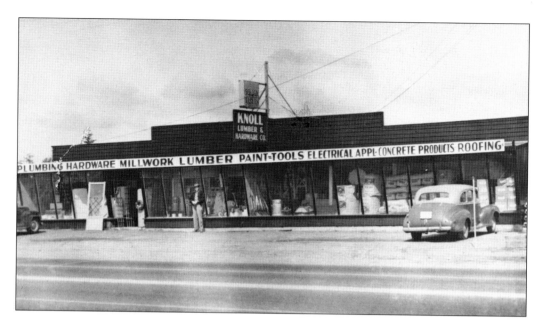

Phil Eichholtz purchased the Knoll Lumber and Hardware Company (above) at South 309th Street and Pacific Highway South in 1954. He used the existing site for one year before building the New Lumber and Hardware Company (below) one block north. Eichholtz added a lumberyard and eventually remodeled the building. It is currently owned and operated by Eichholtz's two sons, Jim and Bill. The original hardware store, built in 1948, has since served various businesses. The location now houses Bucky's Muffler Shop. (Both courtesy Jim Eichholtz.)

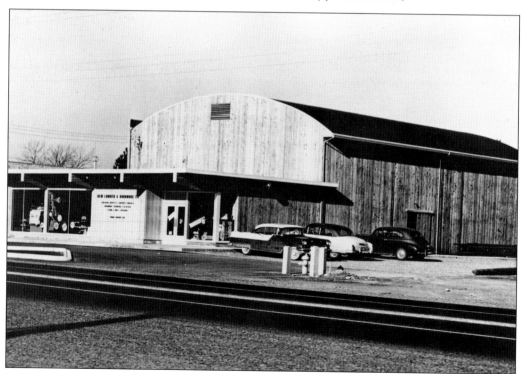

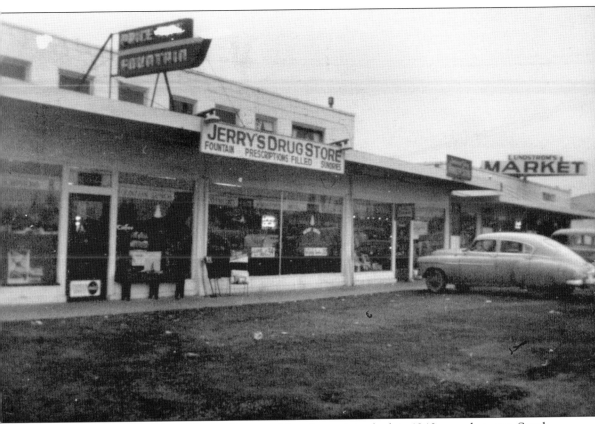

Jerry's Drugstore, Machletts Variety Store, and Lundstrom's in the late 1940s were between South 308th and 312th Streets along Pacific Highway South. Jerry's Drugstore included a pharmacy, sundries, and a soda fountain. Dr. Bertold Bruell, Federal Way's first physician, opened his office on the second floor in 1951. Lundstrom's Market was built in 1945 and was one of the few markets in the area until the roof collapsed in 1949. (Courtesy Daisy Ness.)

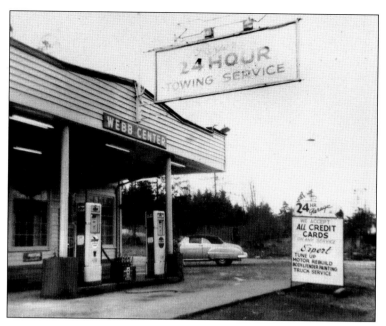

The Webb Center garage, featuring Rogers 24-hour Towing Service, was built by Andrew Kristensen around 1933 at the southwest corner of South 320th Street and Pacific Highway South. This garage and small grocery store was one of the first businesses on what would eventually become a very busy corner. The Bank of America currently occupies this space. This photograph was taken in the early 1950s. (Courtesy Dorothy Rogers.)

The mink ranch at 2215 South 312th Street was nearly surrounded by trees in the late 1950s when this aerial photograph was taken. It was owned by Jack and Eileen Ruoss. It was one of several mink, chicken, and turkey ranches in the area. This property currently includes numerous businesses, such as Wal-Mart and Hillside Plaza. (Courtesy Eileen Ruoss.)

After working together as gardeners in Tacoma for 17 years, Joe Asahara (left) and Kenneth Hikogawa went into business for themselves. In 1960, they opened the Federal Way Garden Center at the old Federal Way Shopping Center. The business was later relocated to its current location at 30650 Pacific Highway South and renamed Oriental Gardens, Inc. Family members currently operate the store. (Courtesy *Federal Way News*.)

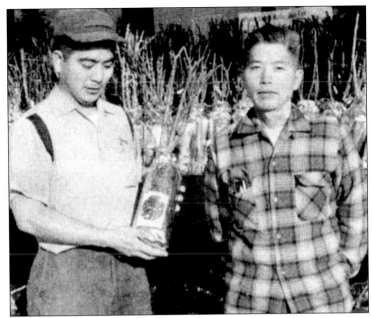

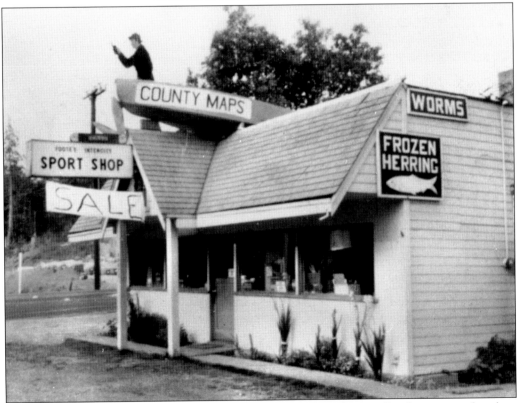

Foote's Intercity Sport Shop at Pacific Highway South and Dash Point Road was a popular place for sportsmen during the 1950s and 1960s. It was owned and operated by Jay and Bertha Foote. The couple moved to Federal Way in 1938, opened a repair shop in 1946 at this location, and then opened the sports shop in 1952. It remained open until 1969. (Courtesy Bertha Foote.)

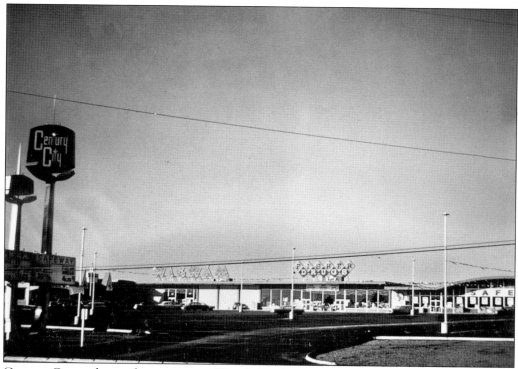

Century City at the southwest corner of South 320th Street and Pacific Highway South started adding businesses in the early 1960s. Wigwam and Fisher Drugs opened in 1963, followed by Safeway in 1964. The Safeway store included 20,000 square feet and employed 35 people. It was one of the first grocery stores to include an in-store bakery. The shopping area is now called Celebration Center. (Courtesy Federal Way School District 210.)

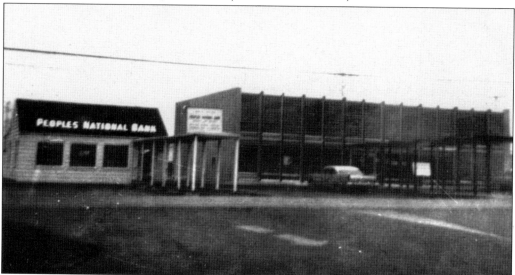

In 1961, the Peoples National Bank of Washington at the northwest corner of Pacific Highway South and South 312th Street used a former antique store as temporary headquarters while a new bank was being built. Opened in 1957, this was the first commercial bank in Federal Way. It is now called U.S. Bank.

Prices were lower in 1963 when Guy Mark and Frank Spane opened Frank and Guys Market in the Federal Shopping Way, on South 312th Street. They featured a full-sized steer in front of their market as well as old-fashioned advice and wholesale and retail meats, sausage, seafood, and dairy products. Tom Spane, Frank's son, bought Mark's share in 1981 and ran the business until it closed in 2007. (Courtesy *Federal Way News*.)

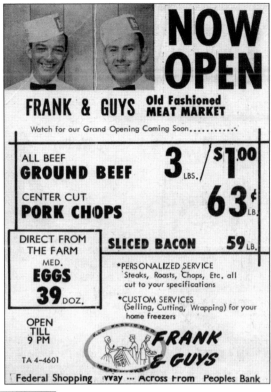

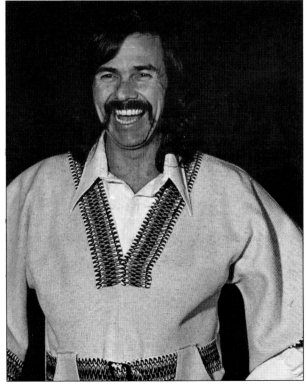

Dick Balch put Federal Way on the national map in the 1970s with his wild laughter and fender-smashing television campaigns for Chevrolets. His business flourished. At one point, he claimed his business was grossing $16 million a year. By 1980, he was bankrupt and $2.7 million in debt. Asked why his business failed, he blamed high interest rates, inflation, and public distrust of the country's financial health. (Courtesy Marie Sciacqua.)

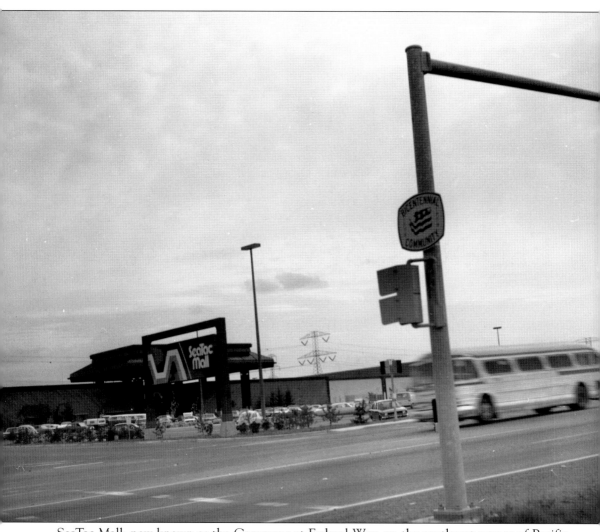

SeaTac Mall, now known as the Commons at Federal Way, on the southeast corner of Pacific Highway South and South 320th Street, opened on August 14, 1975. An estimated 20,000 people visited the 42-store mall the first week. Within a year, there were 90 stores with four department stores. The mall was developed for $35 million by Harry Newman Jr. of Newman Properties and Ernst W. Hahn Inc. (Courtesy Marie Reed.)

# *Seven*

# FEDERAL SHOPPING WAY

J. R. ("Jack") Cissna is considered a founding father of the modern development of Federal Way. Cissna was a creative developer, flamboyant, eccentric, and successful. Cissna developed an early shopping center in Federal Way that was way ahead of its time based on the population of the area. It not only contained stores but an amusement center, a collection of historic buildings, and facilities for a variety of activities, such as a roller-skating rink.

Cissna opened his own life insurance company, Federal Old Line Insurance, in Seattle in 1937. The name of the insurance company and the area of Federal Way are a coincidence, and one is not based on the other. By 1946, Federal Old Line Insurance had become the leader in life insurance sales in the state of Washington.

Cissna decided the big-city Seattle location for the insurance company was no longer practical, so he began looking for a new location and a reason to move. In the early 1950s, many entrepreneurs were searching for opportunities to leave the cities and move into growing suburbs. Cissna decided the undeveloped Federal Way area was ideal for the development of a large shopping center. The location was roughly halfway between Seattle and Tacoma and on a major road, Pacific Highway South. Investing in the development of the center would help Federal Old Line Insurance increase its assets.

The area southwest of the intersection of Pacific Highway South and South 312th Street was heavily wooded and swampy prior to the 1950s. In early 1954, Ilene and Francis Marckx sold their farm store and 2.5 acres of land on the southwest corner of the intersection to Cissna. He moved his Federal Old Line Insurance Company into the remodeled building. By May 1954, Cissna had purchased 20 acres at this location. Several companies that Federal Old Line Insurance had worked with in the past and individual investors in the community came together to help with the financing to develop, own, and operate this planned shopping center. Over the years, investors bought into varied aspects of the development.

J. R. Cissna was born in Bellingham, Washington, in 1908. He graduated from the University of Washington Law School. He married Evelyn in 1939. In 1954, Cissna began to move his operations from Seattle to the undeveloped Federal Way area. Cissna is pictured here around 1958. (Courtesy Evelyn Cissna.)

In early 1954, Cissna started to develop a large shopping center with stores, an amusement area, historical buildings, and outdoor activities. This photograph shows the land cleared for development, with only the former Marckx Farm Store on the site. This building became the headquarters building for Federal Old Line Insurance. (Courtesy Greater Federal Way Chamber of Commerce.)

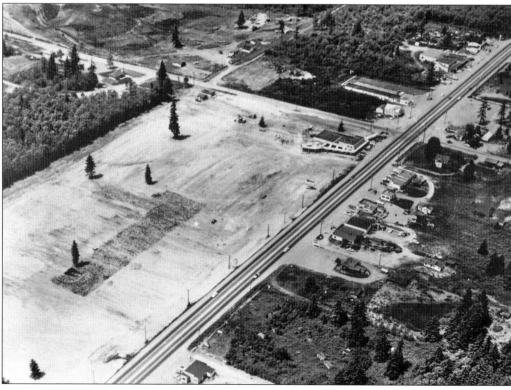

Construction of the mall buildings began in the summer of 1954. This is an early board of directors meeting. Three key personalities are Harold Watkins, president (first row, second from left); J. R. Cissna, chairman of the board (first row, center); and C. Ralph Fleming (second row, far left), leading area real estate promoter. (Courtesy Evelyn Cissna.)

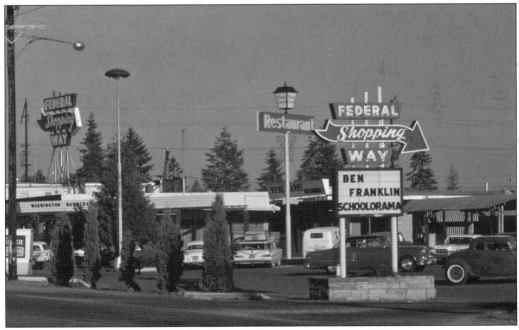

Federal Shopping Way was authorized to commence business as a Washington corporation on May 24, 1955. It became the first large shopping center in the area and was also a center for recreation and educational activities. The two large signs shown became landmarks for the area for more than 20 years. (Courtesy Evelyn Cissna.)

Federal Shopping Way was partially financed by selling stock certificates. The example shown is from 1956. It represents 30 shares at a par value of 75¢ per share. The total for this issue was three million shares. Expansion plans over the next 10 years led to many different ways to finance the shopping center. (Courtesy James Morgan.)

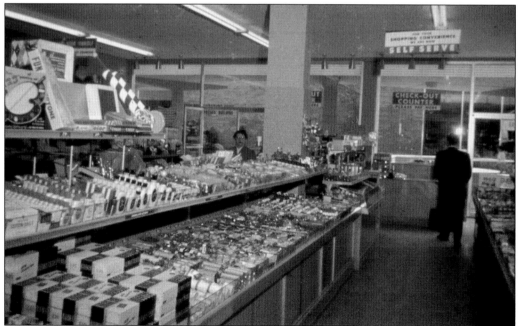

As early as January 1955, some of the stores in the mall were open for business, with others promised almost immediately. The photograph shows the interior of the Ben Franklin Variety Store. Other early stores were Ostlund's Shoe Store, Federal Way Appliance, University Film, Intercity Publishing Company, the *Federal Way Review*, Federal Old Line Insurance Company, Carlton's Garden Shop, and attorney John Bocek. (Courtesy Evelyn Cissna.)

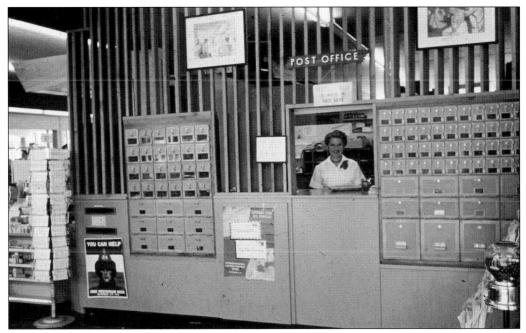

The Federal Way Post Office opened in its own space on April 1, 1955. Prior to this, only small post offices sharing space with other businesses operated in Federal Way. This central post office enabled the rural stations to be discontinued, and Federal Way residents could use a street address. (Courtesy Evelyn Cissna.)

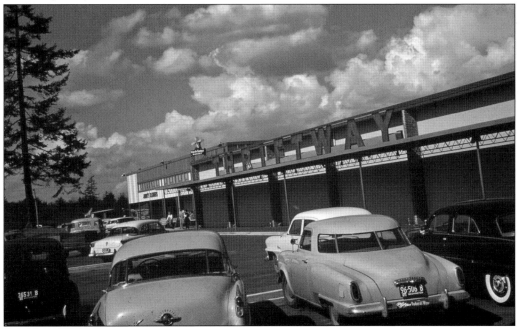

The 15,000-square-foot Thriftway Super Market opened on the grounds of Federal Shopping Way on April 28, 1955. This provided mall shoppers with the largest grocery store in the area. One of the yearly highlights for this supermarket was the display of the championship unlimited hydroplane *Miss Thriftway*. The store closed in 1975. (Courtesy Evelyn Cissna.)

**FEDERAL WAY**

*Review*

JULY 21, 1955

15¢

ANNUAL $1 PER YEAR

VOLUME I, NUMBER 46

Clifford Olson, 10-year-old son of Mr. and Mrs. J. E. Olson, of Federal Way, was the lucky winner of this Shetland pony in the recent contest, sponsored by merchants in Federal Shopping Way. Contestants were required to finish a statement, "I want to be inoculated against polio, because . . ." in 15 words or less. Clifford's entry was selected as the winner by Judges Joanne Erickson, Lillian Moncher, and Marian Rued. This was the second such contest.

The shopping center promoted itself with contests of various types. For example, during the first year of operation, a contest was held to win a pony. The winner, shown on his new pony, is Cliff Olson. The *Federal Way Review* was published weekly by Federal Shopping Way for several years as a general newspaper, but most of the articles and advertising were related to the shopping center. (Courtesy Evelyn Cissna.)

Federal Shopping Way became more than just a mall when construction of SantaFair began in 1962. SantaFair consisted of more than 75 carnival rides, entertainment venues, restaurants, exhibits, and outdoor activities. These included a roller-skating rink, bowling alley, hippodrome (arena), and two theaters. The roller-skating rink is shown under construction. (Courtesy Evelyn Cissna.)

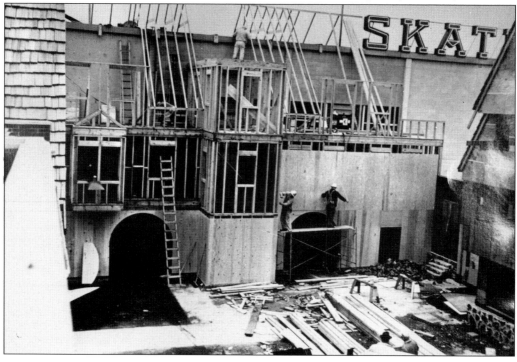

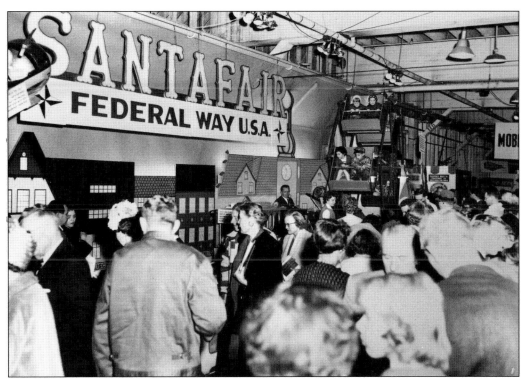

SantaFair was intended to help draw crowds to the stores and also be a moneymaker. This early-1960s photograph shows an exhibit at the Seattle Home Show promoting SantaFair. Note the small Ferris wheel used as part of the promotion. (Courtesy Evelyn Cissna.)

To create a more international flavor, J. R. Cissna imported two double-decker buses from England to use on the grounds and for tours. One of these is shown being unloaded from the ship that brought it from London. Cissna used a train on tracks circling the grounds, a train on tires moving through the grounds, and these buses to transfer people around the 20-acre complex. (Courtesy Evelyn Cissna.)

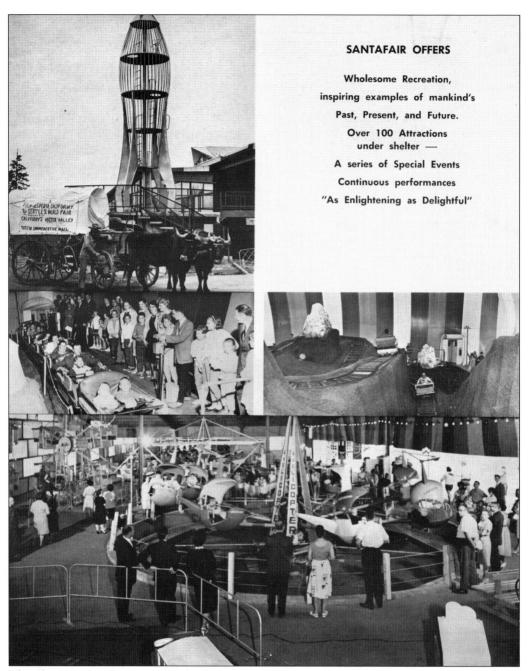

**SANTAFAIR OFFERS**

Wholesome Recreation,
inspiring examples of mankind's
Past, Present, and Future.

Over 100 Attractions
under shelter —

A series of Special Events

Continuous performances

"As Enlightening as Delightful"

This photograph is from a 1963 Federal Shopping Way promotional brochure advertising SantaFair. (Courtesy Evelyn Cissna.)

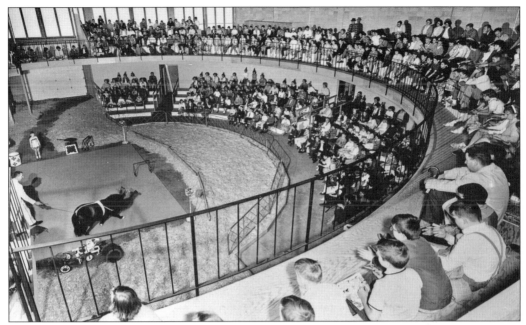

Shown is a 1963 wide-angle view of the interior of the SantaFair Hippodrome. More than 100 people are pictured on the main floor and in the balcony watching the Hapsburg Society Circus. The Hapsburg Society Circus performed regularly with chimps, seals, horses, and dogs. They were often seen on the *Ed Sullivan Show*. (Courtesy Evelyn Pattison.)

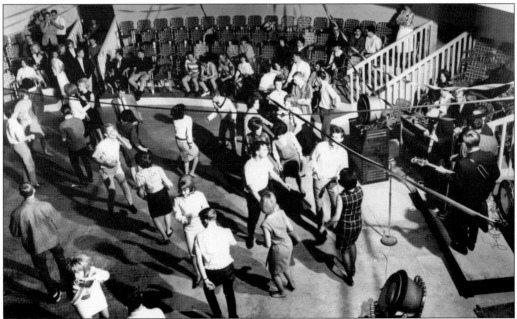

About 30 high school students are shown dancing in the SantaFair Hippodrome in this 1960s photograph. The Hippodrome was designed after European structures that traced their origin to the historic Hippodrome of Constantinople, built in 250 A.D. SantaFair, with its Hippodrome, skating rink, carnival rides, and numerous activities, provided a wide variety of things for children and teenagers to do. (Courtesy Evelyn Pattison.)

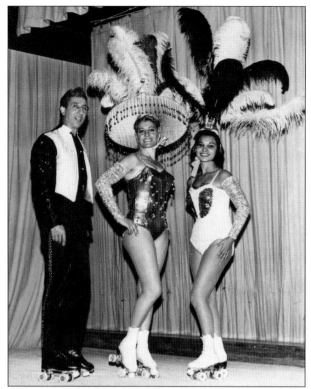

In the 1950s and 1960s, roller-skating was very popular around the nation. Roller-skating acts and competitions were well received as entertainment. In addition to having a rink for individual skating, professional shows and competitions were held at SantaFair. This is a 1960s photograph of two women and a man posing in their show costumes. (Courtesy Evelyn Pattison.)

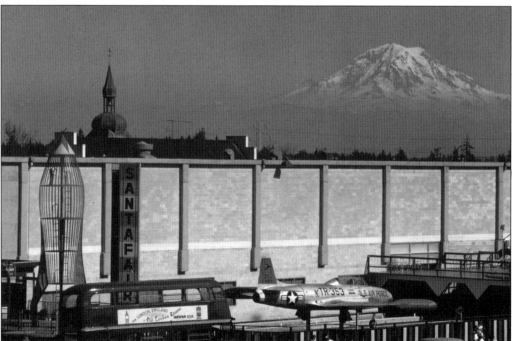

Several outdoor exhibits, such as this jet trainer that Cissna obtained from the air force, were displayed on the grounds. Old World Square was located where the tall clock tower is shown. Mount Rainier could be seen from many places on the grounds. (Courtesy Evelyn Cissna.)

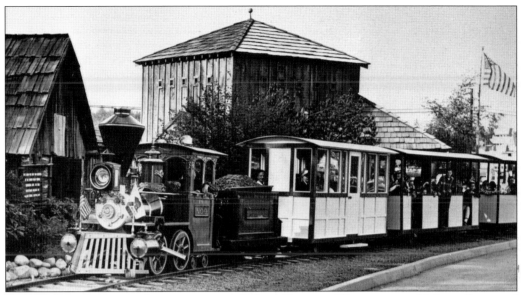

Cissna felt another way to draw customers to Federal Shopping Way was to establish a collection of historic buildings to be called Historic Park. The northwest and southwest corners of the grounds were used. In 1955, the historic 1883 Barker Cabin (left) was moved from several blocks west. A narrow-gauge railroad opened in 1963 to circle the grounds and provide free rides. (Courtesy Evelyn Cissna.)

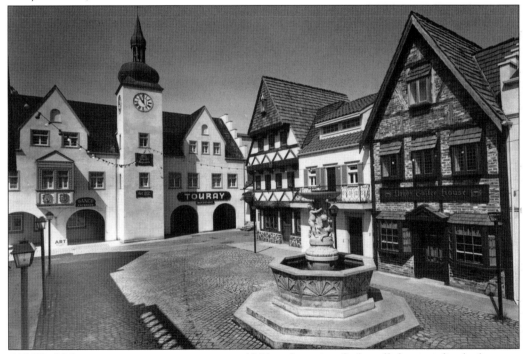

Old World Square was put into operation in 1964 and consisted of small shops and a clock tower. It was designed as a composite reproduction of a European village square. A central feature was a duplicate of Shakespeare's study. In the center was a reproduction of the Singing Fountain of the Four Children. (Courtesy Evelyn Cissna.)

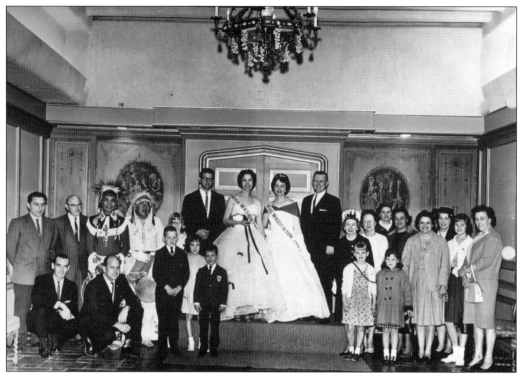

Special functions were held at the Castle of Aix at SantaFair. Shown here is the crowning of Mrs. Washington for 1963. The Castle of Aix simulated the one from France with 16th-century paintings on canvas panels and a chandelier that originally had candles with glass fruit hanging down. Heinz Ulbricht (back left) was the German designer of Old World Square. Evelyn Cissna is shown third from right, and the Mrs. Washington on the right is Mrs. Neal. (Courtesy Evelyn Cissna.)

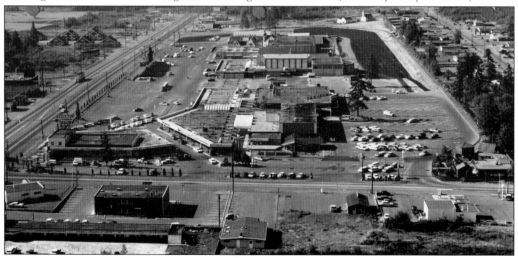

A 1960s view of Federal Shopping Way is shown. The original Marckx Building that became the Federal Old Line Insurance office is seen on the left. Historic buildings can be seen on the lower right of the shopping center. In the far distance are some other historic features, such as St. Claire's Indian Mission Church, brought from the nearby Muckleshoot Reservation. The railroad tracks circling the grounds can just barely be seen.

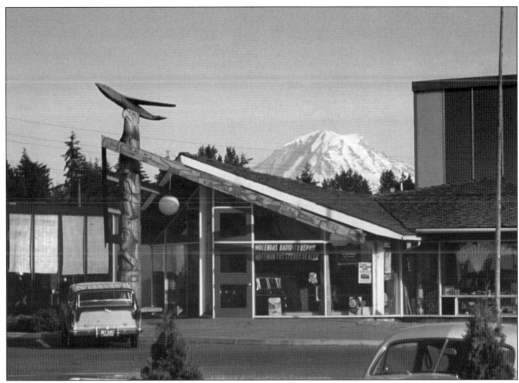

By 1957, a hand-carved totem pole honoring the natives of Alaska was a feature. On top of the totem pole was a jet-shaped bird symbolizing the coming of the jet age. Looking to the southeast from Federal Shopping Way is Mount Rainier about 40 miles away. (Courtesy Evelyn Cissna.)

J. R. Cissna (left) is excited about the construction of Federal Shopping Way in 1955. Unfortunately, financing fell apart in the mid-1960s. In 1967, Federal Shopping Way faced bankruptcy. A series of lawsuits followed over the next 15 years. The original Federal Old Line Insurance Company was taken over by the state insurance commission, with most of its assets tied up in the shopping center. (Courtesy Evelyn Cissna.)

Between 1970 and the mid-1990s, all the buildings of Federal Shopping Way were demolished. Shown is the top section of the clock tower from Old World Square. A new shopping center, Pavilions Centre, occupies the site now. St. Claire's Indian Mission Church was returned to the Muckleshoot Reservation. The Barker and Denny Cabins are now displayed at West Hylebos City Park. (Courtesy Lynda Jenkins.)

The Cissna family members—from left to right (first row) Sharon, Kent, Evelyn, Scott, and Heather; (second row) Robert and J. R.—are in front of their home, the Castle at Redondo, in 1962. J. R. Cissna died in 1986. Evelyn Cissna now lives in Rainier, Washington. (Courtesy Evelyn Cissna.)

# *Eight*

# CULTURAL AND SOCIAL ACTIVITIES

During the time of initial settlement and growth, people were isolated into small pockets and had to depend on each other for entertainment and support. This took the form of picnics, religious activities, community clubs, and Grange activities.

Neighbors lived a moderate distance from each other, and it was difficult to get through wooded and swampy areas. This made getting together an event. Opening a small school created the need for families to come together for a mutual cause.

Religious activities were often held in homes and schools before 1920. Very little is known about churches before 1920. In addition to the local residents participating in religious activities, people came from Seattle and Tacoma to enjoy the rural atmosphere and the spiritual environment found in Christian campgrounds. At least three campgrounds developed in the area: the Methodist, Epworth Heights; the Lutheran, Lutherland; and Bethel Gospel Park, sponsored by an independent church in Seattle, Bethel Temple.

The National Grange was originally an association of farmers organized in various chapters for mutual benefit, welfare, and advancement. Locally, people constructed a Grange building that was available for all kinds of activities beyond farming. Dances, religious activities, potlucks, and traveling entertainment could take place at the Grange hall. Many Granges had harvest festivals, which grew into fairs with parades and carnival activity.

The Granges gave way to non-farm-related community clubs that anyone could join. They provided an opportunity for mixing of people in one small community with those in other communities. Local residents ran these various clubs. In the 1930s, national service and fraternal organizations, such as the Lions and Rotary, began forming chapters in Federal Way.

The consolidation of the five small school districts into one large Federal Way School District in 1929 meant people from all over the community had a common reason for getting together. At first, this was for educational reasons, but the need for a supporting PTA and lunch programs brought the people together in a social environment.

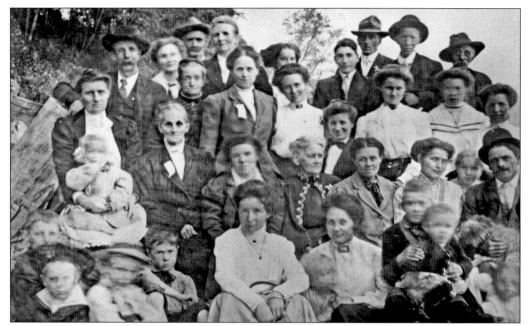

A group of Star Lake residents is seen posing at a picnic near the Stone's Landing beach area around 1900. The isolated pockets of people tended to stay together in their activities and had little exchange of activities with other isolated pockets of people only a few miles away. It would appear people dressed a little more formally for picnics 100 years ago. (Courtesy Luella Hilby.)

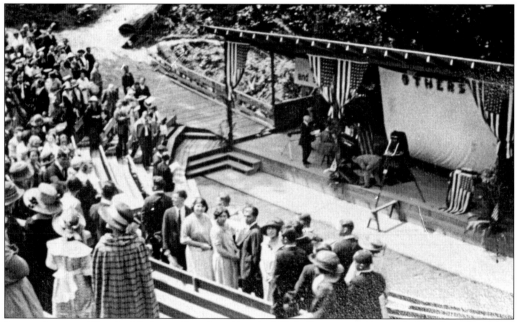

Located west of Pacific Highway South at South 288th Street was Epworth Heights, a 40-acre Methodist church camp overlooking Puget Sound. People came and often spent several weeks in tents and cabins, listened to music and sermons, and enjoyed the rural atmosphere away from Seattle and Tacoma. Most of the attendees came from Seattle. This is a 1920s audience gathering in the amphitheater for a presentation. (Courtesy Craig Brown.)

Campers from West Seattle are shown spending time at Epworth Heights around 1920. The campground was on the plateau above Redondo Beach, so it was only a short walk to the beach for a swim or picnic. During the early years, as many as 500 campers, worshippers, and staff could be found on the grounds during the summer months. Epworth Heights closed in 1962. (Courtesy Craig Brown.)

Lutherland was another early church campground. It opened on the southwest shore of Lake Killarney in 1938. People pose in front of the chapel in 1954 during Calvary Lutheran Church's organizational meeting. The congregation moved into a new church in 1956. The only remains of Lutherland are the steps the people are standing on in this photograph. (Courtesy Calvary Lutheran Church.)

In 1936, Bethel Temple of Seattle opened a campground on 29 acres of land next to Mirror Lake along South 312th Street for use as a church campground and a home for missionaries. People who stayed for a week or two used tents and small cabins. The complex, although reduced in size, is still in operation. Shown are attendees in 1948 outside the main chapel. (Courtesy Bonnie Branner.)

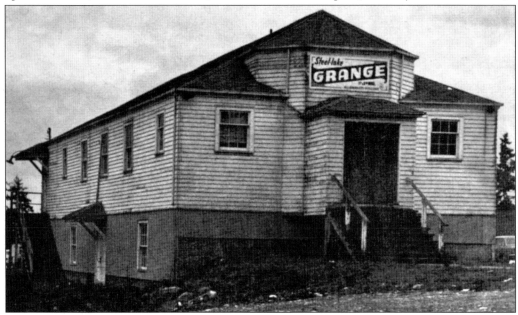

The first Steel Lake Grange Hall was built in 1924, at South 288th Street and Military Road South. The initial membership was 28. In 1938, the first hall was destroyed by fire and a second was constructed at the same site. In 1972, the Steel Lake Grange Hall was demolished to make room for a service station. The photograph shows the hall in 1972 before demolition. (Courtesy *Federal Way News*.)

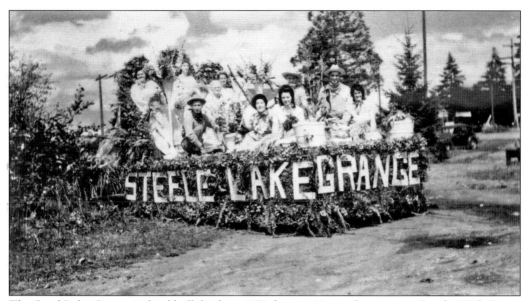

The Steel Lake Grange's third hall, built in 1972 for its 400 members, was at South 288th Street east of Military Road South. A Grange function was an important center of activity for these small communities. Shown is a 1948 Steel Lake Grange float prepared for an unknown event. This Grange hall was recently torn down to make room for a housing development. (Courtesy Florence Kravik.)

The predecessor of Steel Lake Presbyterian Church started a Sunday school in the Steel Lake Grange Hall in 1928. Even after the church was organized in 1948, the Grange hall at South 288th Street and Military Road South was often used for activities. Shown is a group of young people in 1949 dressed for an Easter pageant.

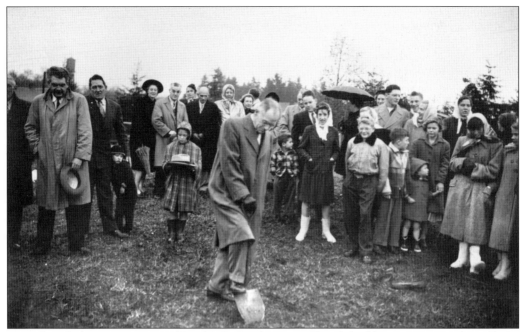

Even though the congregation of Steel Lake Presbyterian Church had been meeting informally for many years, the congregation was not formally chartered until 1948. Shown is the 1950 groundbreaking for the church at 1829 South 308th Street. Note the girl holding the hat of the person breaking ground. (Courtesy Ila Mae March.)

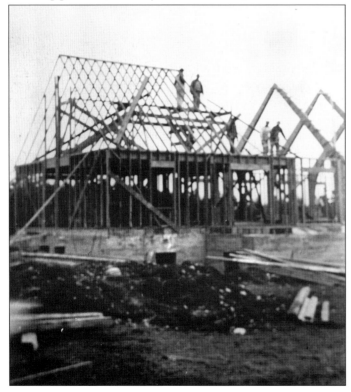

Steel Lake Presbyterian Church, shown here under construction in 1951, held the first services at the church in 1952. It has continued to grow and has added many new facilities over the years. The 1950s and 1960s saw many other churches opening in the area. This indicated that the area was growing in other ways, too.

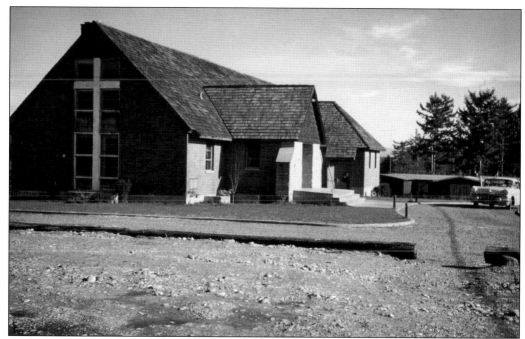

Other churches opening in the area in the 1950s and 1960s included First Baptist Church in 1955, Calvary Lutheran Church in 1956, Nine Lakes Baptist Church in 1962, Church of Jesus Christ of Latter-day Saints in 1963, St. Luke's Lutheran Church in 1964, and St. Vincent DePaul Catholic Church in 1965. Shown here as it looked in the early 1960s is the Steel Lake Presbyterian Church.

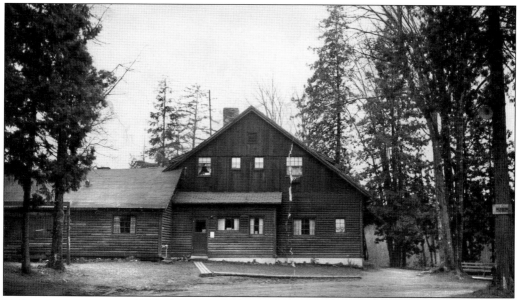

Built as a restaurant in 1920, this structure at 726 South 356th Street has had a colorful past as it served a wide variety of functions: a speakeasy during Prohibition, a brothel, at least two restaurants, and a gambling den. It sits on the edge of a small lake called Brooklake. It is shown here in the 1950s. The building, with modifications, still exists.

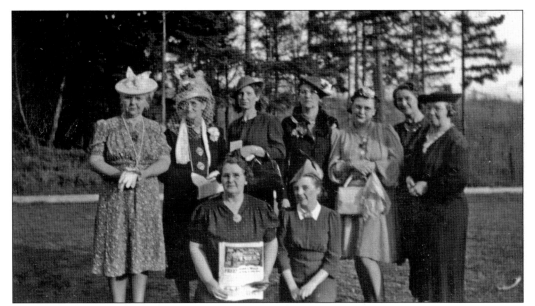

The Harding Improvement Club was originally organized in the 1930s to help victims of the Depression. Shown are members of the 1936 Harding Women's Club. In 1943, the Harding Improvement Club acquired the 18-acre lake and the Brooklake Building and changed its name to the Brooklake Community Club. In 1944, the Brooklake Women's Club organized a community library. There were 110 registered borrowers and 1,782 books when the library closed in 1955.

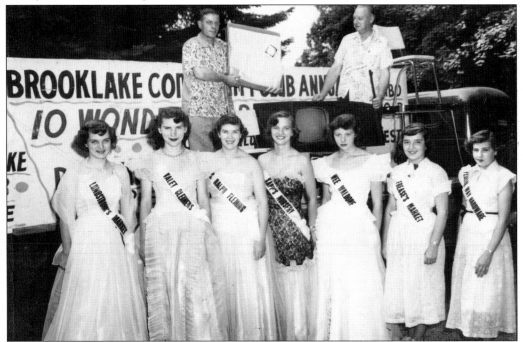

Any event would usually be a good enough reason for an organization to have a beauty contest. Shown is the 1950 Brooklake beauty pageant for the annual barbeque. The girls have banners that represent local merchant sponsors. The men in the truck are showing a television set and rifle—prizes in the raffle. (Courtesy Ila Mae March.)

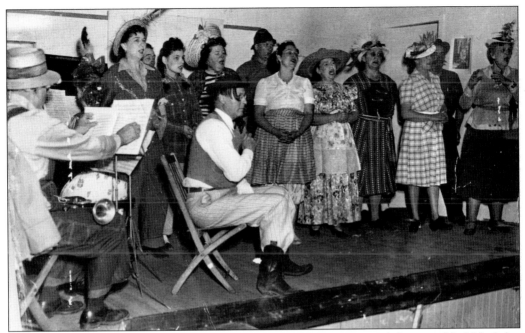

The Brooklake Community Club sponsored dances, put on annual fairs, and held holiday celebrations. Shown in the late 1940s is a fall variety show performance by the Brooklake Hillbillies. The club prospered in the 1950s but did not have money to pay taxes after the early 1960s. Ralph Fleming is seated in the front center, and Nellie Fleming can barely be seen playing the piano. (Courtesy Carol Houston.)

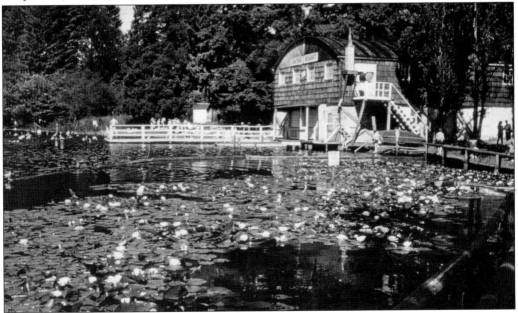

Federal Way has several large lakes. Each one of these had at least one dance hall and resort. Starting in the 1920s, these provided a place for swimming, picnics, vacations, dances, and community activities. Shown here in the 1950s is one of the two resorts that were at Steel Lake. The sign on the building reads, "Lakedge Resort." (Courtesy Bill Sherwood.)

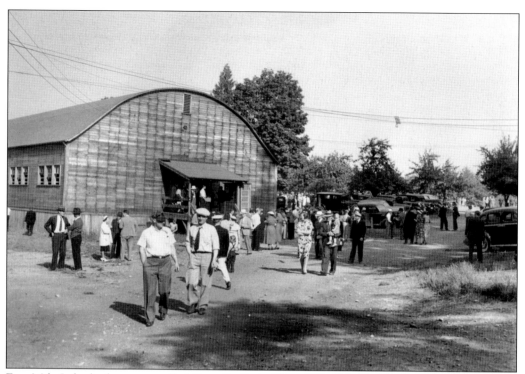

Five Mile Lake had a resort called Scandia Park. This 1938 photograph shows members of the Pacific Coast District Grand Lodge of the Sons and Daughters of Norway mingling after a picnic. The dance pavilion in the background was torn down in the late 1950s. The only remnant of these dance halls still remaining is the Star Lake Inn. (Courtesy Tacoma Public Library, Richard's Studio D7340-4.)

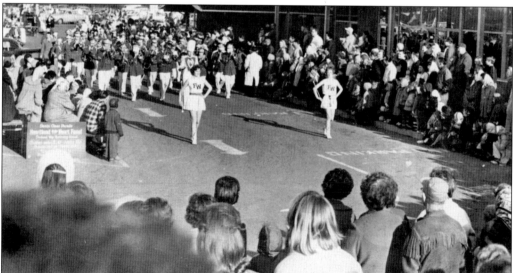

With the 1929 formation of one school district, an active chamber of commerce in the 1950s, and the opening of Federal Shopping Way in 1955, there was a centralization of the area's activities. This is a 1960s-era photograph of a Santa Claus parade being led by the Federal Way High School Band through the parking lot of Federal Shopping Way. (Courtesy Evelyn Cissna.)

Federal Shopping Way provided a venue for the entire Federal Way community to get together for activities. One activity was to sponsor beauty pageants. The first Miss Federal Way was selected in the 1940s. Shown is the 1957 swimsuit contest for Miss Federal Way held at Federal Shopping Way. (Courtesy Ilene Marckx.)

Miss Federal Way and her princesses attended local and regional functions promoting Federal Way. Shown here is the Federal Way float entered in the Tacoma Daffodil Festival Parade in 1955. By the 1980s, lack of interest and available sponsors greatly reduced community participation in these types of activities. (Courtesy Ralph Hose.)

Not all beauty pageants were conducted with seriousness. Shown is a 1956 contest for Mrs. Star Lake with the contestants in bathing suits from the early 1900s. (Courtesy Luella Hilby.)

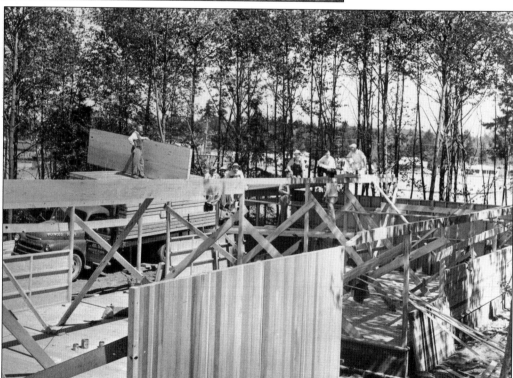

In 1954, the Greater Federal Way Chamber of Commerce built and raffled a house to help promote the area. The house was constructed with volunteer labor and material, and the proceeds were to be used for youth programs. After a lot of work and promotion, the raffle only raised $127.37 after expenses were paid. (Courtesy Kenneth F. Severa.)

Service and fraternal organizations and clubs, such as the Lions, Rotary, and Kiwanis, became prominent in community affairs. In addition to holding meetings and activities for their own members, they often held fund-raisers for various local causes. Shown here is the stage and audience getting ready for a 1956 Lions Club performance of the musical *Bosenglas, By Cracky!* Sponsorship signs are seen on the stage. (Courtesy Nellie Fleming.)

The Federal Way Kiwanis Club began having annual salmon bakes in 1957, now held at Steel Lake Park. The event has a menu that features alder-smoked salmon. The first few events drew about 500 people with a steady growth to about 1,000. Profits are given as scholarships or for other community causes. Local politicians attend, but they are not allowed to pass out literature. Shown here are salmon being grilled in 1968. (Courtesy *Federal Way News*.)

Politics have always been important to the people of Federal Way. Shown here are Shirley Charnell (left) running for the state legislature in 1974, Gov. Dan Evans (center), and George Galteland. Charnell lost the election but over the years held many civic positions. From the 1970s, she was a major force on the community council and worked for 20 years on Federal Way's incorporation.

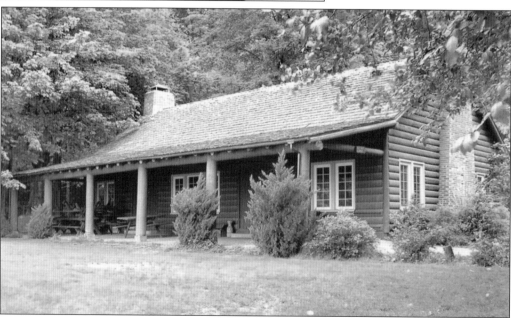

Boy and Girl Scout programs became active here during the 1930s. Camp Kilworth is a 35-acre site on Puget Sound deeded to the Boy Scouts in 1934 by William and Francis Kilworth. It remained undeveloped as the surrounding area became urban and provided an opportunity for Boy Scouts from western Washington to come and camp. This recent photograph shows the main lodge, built in 1936. (Courtesy Hazel Dickinson.)

# Nine

# BECOMING A CITY AND BEYOND

Many people moved to Federal Way after Interstate 5 was completed in the 1960s. It was an easy commute to either Seattle or Tacoma for employment opportunities, and the area offered a quiet, less complicated lifestyle that families found inviting. Trees, lakes, mountains, and Puget Sound framed the growing suburban community. Newer schools and affordable housing attracted young families. As large parcels of land became serviced by sewers and water, people had their choice of many developments with either single or multi-family housing. But what seemed ideal at first quickly changed.

During this period of rapid growth, Federal Way was a sprawling suburb governed by King County. It grew quickly and randomly, resulting in crowded schools, roads, and services, all of which exceeded capacity. Single- and multi-family subdivisions were approved throughout the area, also taxing fire and police protection. Federal Way had the highest growth rate in the state.

By the early 1970s, residents became increasingly frustrated and decided that the only way to control future growth was to see that Federal Way became a city. But voters, along with many developers who were fiercely opposed, did not agree. The first attempt was voted down in 1971. Two additional efforts to incorporate in the 1980s also failed, primarily because of opposition from families who lived east of Interstate 5 and in Redondo. In 1989, organizers reduced Federal Way's proposed boundaries to include only those neighborhoods that supported city-hood. Voters approved the ballot on March 14, 1989, and Federal Way officially became a city on February 28, 1990.

A large group of people laid the groundwork for the new city, including a transition team that took Federal Way from being part of unincorporated King County to becoming a first-class city. The first Federal Way City Council election was held on September 19, 1989.

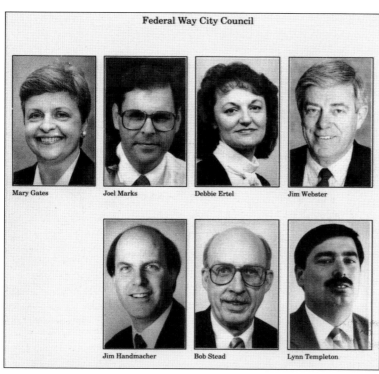

### Federal Way City Council

Mary Gates　　Joel Marks　　Debbie Ertel　　Jim Webster

Jim Handmacher　　Bob Stead　　Lynn Templeton

Fourteen people ran for election to the first city council. The candidates came from varied backgrounds. The first Federal Way City Council election was on September 19, 1989. Those elected are shown here.

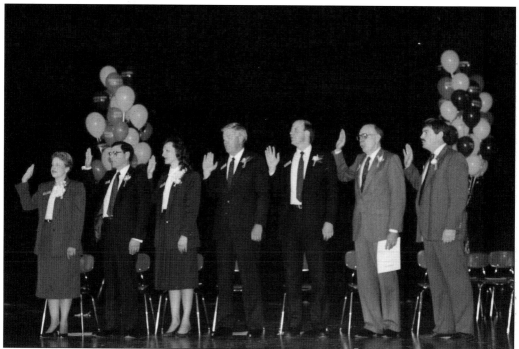

The swearing-in ceremony of the first Federal Way City Council took place on September 30, 1989, at Decatur High School, at Southwest 320th Street and Twenty-sixth Avenue Southwest, in Federal Way. The new council members were sworn in by Judge Carolyn Hayek, Federal Way District Court, and Justice James D. Dolliver, Washington State Supreme Court. (Courtesy Ed Opstad.)

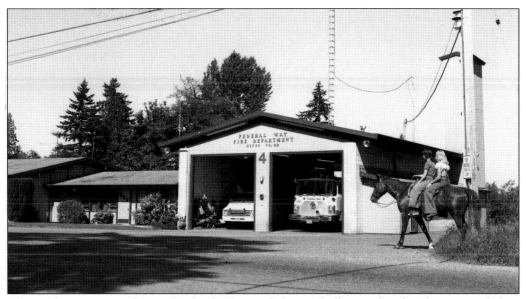

The newly incorporated city of Federal Way needed a city hall immediately. The city needed an address, a phone number, a place for city council meetings, city employees, and most importantly a place residents could call their own government building. A structure the Federal Way Fire Department owned at South 312th Street and Twenty-eighth Avenue South was selected for temporary use. (Courtesy Marie Reed.)

In 1991, the city council purchased the first city hall. It was located at the corner of South 336th Street and First Way South. A few years later, the city formed a police department. More space was required. The city eventually purchased a larger building, with room for all departments, including the municipal court. It is located at 33325 Eighth Avenue South. (Courtesy City of Federal Way.)

One of the city council's first controversial decisions was to purchase the former Evergreen Air Park. In December 1990, the council voted 5-2 to buy the 83.5-acre parcel for $12.5 million. To pay for the land, the council increased the real estate excise tax 0.25 percent. This park would eventually become Celebration Park. (Courtesy Marie Sciacqua.)

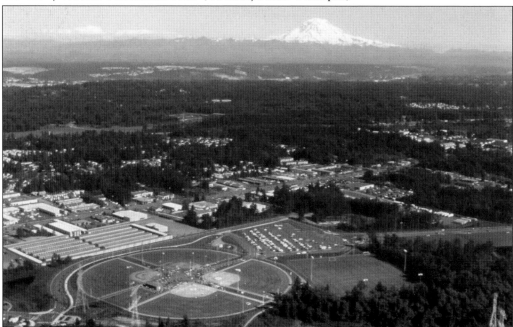

Celebration Park is located in the heart of Federal Way. It was designed to offer varied activities, such as baseball, soccer, trails, and playgrounds, all within reach of downtown and nearby residential areas. The park is also the location for the city's Red, White, and Blues Festival each Fourth of July and the Federal Way Community Center. (Courtesy City of Federal Way.)

The Federal Way Community Center opened in March 2007. Located in Celebration Park, the center offers a state-of-the-art venue, from a climbing wall to the two pools designed for all ages. A variety of programs and classes are offered throughout the year for residents and nonresidents. (Courtesy City of Federal Way.)

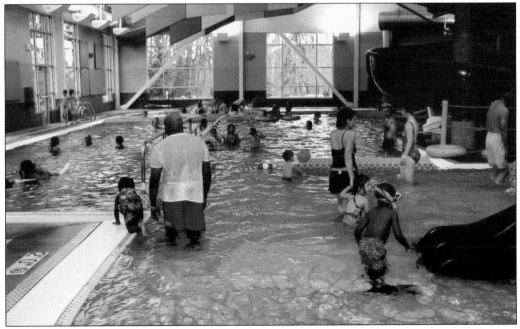

The community center is located on a hill with a southeasterly view of Mount Rainier. It features a six-lane lap pool with diving board, a leisure pool, three gymnasiums, a steam room, three multipurpose rooms, walking/jogging track, aerobics studio, weight and fitness facility, child care facility, senior lounge, and commercial kitchen. (Courtesy City of Federal Way.)

Dumas Bay Centre has been owned and operated by the City of Federal Way since 1993. The property was formerly the Sisters of Visitation Retreat Center. Located on tranquil Dumas Bay, the land was purchased with funds from the 1989 King County open space bond and state shoreline funds. Dumas Bay Centre features the Knutzen Family Theater and a retreat and meeting center, as well as a park with beautiful views of Puget Sound. (Courtesy Marie Sciacqua.)

The Knutzen Family Theatre is a 234-seat, state-of-the art performing arts center completed in 1998. A project of the Federal Way Arts Commission, the theater is named for the Knutzen family, longtime residents and generous contributors to the fund-raising campaign. The family's contribution to "raise the curtain" was given in perpetual celebration of family—past, present, and future. (Courtesy Marie Sciacqua.)

The state granted Federal Way a Certificate of Need when it became obvious the city needed a hospital. St. Francis Health Services purchased a 22-acre site at South 348th Street and Ninth Avenue South in 1984 from the Quadrant Corporation. Construction of the St. Francis Community Hospital began in 1985. The hospital was dedicated on May 2, 1987. (Courtesy *Federal Way News*.)

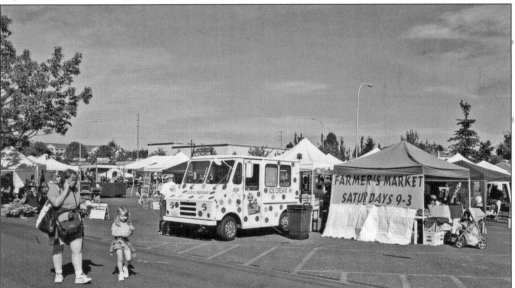

The Federal Way Farmers Market opened on June 19, 2004, and is held in front of Sears at the Commons at Federal Way on Saturdays from May to October. It is a place where family and friends can gather and buy local fruits, vegetables, cut flowers, bakery products, and local crafts. A master gardener is available for questions on plants, and live entertainment is provided. (Courtesy EdStreitImages.com.)

The Pacific Rim Bonsai Collection, established in 1989, is located within the Weyerhaeuser Corporate Campus. The collection is an outdoor museum of living Asian art elegantly displayed in a woodland setting. It is the only such collection owned and operated by a private corporation. Federal Way is fortunate to be home to such a valued collection, widely regarded as one of the finest in North America. (Courtesy *Federal Way News*.)

About the time Federal Way became a city, Washington voters approved the Growth Management Act. Each city is required to provide housing for population growth. After many community meetings and hearings in 2007, the city council approved a high-rise, mixed-use development for the city center. The project is named Symphony. It will include offices, shops, restaurants condominiums, and a 1-acre public park. (Courtesy VIA Architecture.)

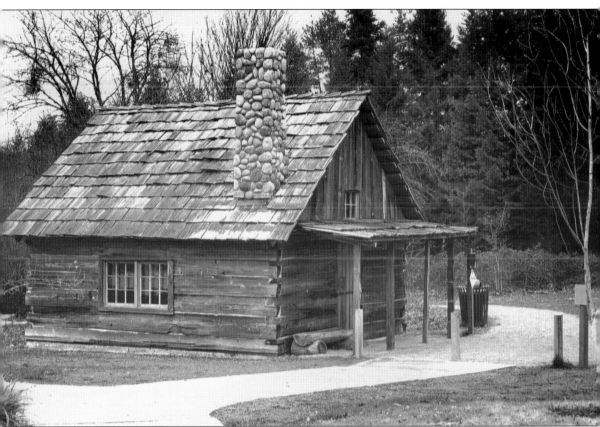

The restored 1880s Barker Cabin (on South 348th Street at the West Hylebos Wetlands Park entrance) reflects an earlier lifestyle and culture that no longer exists in Federal Way. From its humble beginnings, Federal Way has become a prosperous urban community that embraces technology, the environment, and fresh ideas. Federal Way is a diverse community with many cultures. Change will continue, forever imprinted by the footprints of pioneers who first settled Federal Way. (Courtesy Tim Robinson.)

# ACROSS AMERICA, PEOPLE ARE DISCOVERING SOMETHING WONDERFUL. THEIR HERITAGE.

Arcadia Publishing is the leading local history publisher in the United States. With more than 4,000 titles in print and hundreds of new titles released every year, Arcadia has extensive specialized experience chronicling the history of communities and celebrating America's hidden stories, bringing to life the people, places, and events from the past. To discover the history of other communities across the nation, please visit:

## www.arcadiapublishing.com

Customized search tools allow you to find regional history books about the town where you grew up, the cities where your friends and family live, the town where your parents met, or even that retirement spot you've been dreaming about.